CW01021026

ALFRED WALLIS
primitive

SVEN BERLIN

Christopher, 14th March
Happy Birthday 2001

 will love from Manoi

Sansom &
Company

First published in 1949 by
Poetry London/Nicholson & Watson, London

This new edition was first published in 1992 by Redcliffe Press Ltd.
Re-issued in 2000 by Sansom & Company Ltd.,
81g Pembroke Road, Bristol, along with Sven Berlin's article
in *Horizon*, January 1943.

© Julia Berlin

ISBN 1 900178 18 4

British Cataloguing-in-Publication Data
A catalogue record for this book is available from the British Library.

All rights reserved. No part of this publication may be
reproduced, stored in a retrieval system, or transmitted, in any
form or by any means, electronic, mechanical, photocopying,
recording or otherwise, without the prior permission of the
publishers.

New typesetting by Mayhew Typesetting, Rhayader, Powys.
Printed by South Western Printers, Caerphilly, Mid Glamorgan.

Contents

Publisher's note *John Sansom* 4

Cutwater to the second voyage of Alfred Wallis 5

Preface to first edition 10

'The Voyage of Alfred Wallis', *W.S. Graham* 14

 One 15

 Two 20

 Three 25

 Four 33

 Five 37

 Six 44

 Seven 49

 Eight 55

 Nine 62

 Ten 70

 Eleven 80

 Twelve 85

 Thirteen 91

 Fourteen 97

Postscript 100

List of Illustrations 102

Reprint of article in *Horizon*, January 1943 104

Illustrations:

Colour plates between pages 48 and 49

Black & white illustrations between pages 32–33 and 72–73

PUBLISHER'S NOTE

I first met Sven Berlin, then living in a remote game-keeper's cottage near Wimborne, in 1992. We were to discuss the publication of **The Coat of Many Colours**, Sven's memoir of his years in St Ives, but I came away enthused by the prospect of also republishing his long out-of-print life of Alfred Wallis. That new edition, with the author's heartfelt 'Cutwater', was published a few months later and after a few years it, too, went out of print.

The following pages tell the remarkable story of how the book came to be written, under difficult war-time conditions. From those privations came the story of 'a man of gentle light, who was the most misunderstood and exploited artist of our time'. Later research has corrected some of the detail, patiently extracted from Wallis's friends and relatives, and others have since written about Wallis's paintings, but it is hard to see how Sven's empathetic and moving study of the lonely sailor-turned-painter can be surpassed.

Remarkably, although he had the opportunity, Sven never met Alfred Wallis, finally knocking on his door the day after he had been removed to the Madron workhouse. For such an extrovert man, it was a strange omission, which Sven's obituarist in *The Times* perhaps astutely attributed to 'a sort of shyness'.

Sven was rightly proud of this book – to my mind his best, alongside **The Coat of Many Colours** and the controversial **Dark Monarch**, withdrawn in the face of a flood of libel writs in 1962 – as he was of his passionate article about Wallis's fate which appeared in Cyril Connolly's *Horizon* in 1943. The full text of that article, reprinted for the first time, appears on page 104.

Sven Berlin died on December 14th, 1999, and **Alfred Wallis: Primitive** is now again brought back into print as a tribute to a fine artist, writer and friend.

John Sansom
May 2000

Cutwater to the second voyage of Alfred Wallis

Taking my book on Alfred Wallis from the shelf and reading it, fifty years after starting my research to write it, is like discovering a stone tablet on which was written a story of ancient times: perhaps it happened on one of the Greek islands during the Trojan wars, an almost unbelievable experience of one simple sailor telling his tale, not in words but in paint, while the turrets of Troy burned as did those of London in our time.

When my publisher, John Sansom, recently asked if he could republish this book I was pleased because it is one that has been neglected and out of print for so long; even masked by other books on Wallis that talk a lot about art, but in no way seem to understand the forces of history or of human experience which grind that art out of one man as if he were to be crushed like ore that holds the precious radium—or that simple quality of human experience—Truth.

Since the book has been obscured, another generation has grown up and has not been able to read the truth about Wallis—what really happened. My researches started early in 1941 and my experience of the Cornish ten years earlier when the old people were still alive and St Ives was still a fishing village where the night catch was unloaded on the Wharf and the fishermen gutted the larger fish with flashing knives, throwing the entrails to the screaming gulls. It smelt of fish, not of fish and chips. The women made nets at the front doors of the back streets and the men made lobster pots with their rooty fingers. Artists were about but they did not rule, nor did they want to. The place belonged to the St Ives people and if you as much as took a photograph of a fishing boat on Sunday they would threaten to throw you in the harbour. And the pubs had their curtains drawn in daylight so that the chapel goers could not see the others drinking their beer.

When Alfred Wallis gave up going to sea he became a rag-and-bone man. He was known as 'Old Iron', collecting with his Donkey Shay like any coster in London or gypsy in Liverpool. That is the background against which he scraped a living. He was also the first man in St Ives to sell ice cream.

It was much the same in the fields, where the men and women worked with their hands and with horses. I, being a pauper at this time, was receiving 17/- old money a week from the Board of Guardians at the workhouse under the Poor Law, when I was *not* working on the fields among the smallholdings of peasant families. When I was working with them I got a wage of 21/- a week and that is how I came to know them: by hand scythe and horse plough, steam

5

thrasher and binder, hay pike and the long handled Cornish spade; knew their rough humour and tough affection when they knew I could stand up to the work.

One old man who no longer went to sea, used to love to talk about taking out the boat drifting for pilchards, longlining and laying the pots. All the olden ways of catching fish and on one occasion a miraculous draught of fishes with the seine nets. He would stand up on the field using the handle of his spade as tiller and the rolling moors as his boat, with the Atlantic Ocean all around us, telling me of the exciting times when he worked a boat called the *Faithful* with Alfred Wallis: a short, silent and difficult man—suspicious, with outbursts of violence. The fishing and land communities were interlocked. In this way I got to know both.

I was able to go into the cottages lit by oil lamp or candle and talk by the fire, turning the long evenings into a network of colourful stories about their relations, always as with this one person darting in and out of their minds, until several conflicting accounts of one thing resolved into a tiny tapestry of truth which I took home in my memory, for I never needed to make notes, and fitted it into the pattern of my book.

I loved them. I was like a cut potato planted in their earth as I grew to understand them. I fought as a St Ives man in the Invasion of France and signed the contract for the book on D-Day, then went down to the marshalling area to board an LTC as forward observer for the Artillery. From that journey I did not expect to return. But the book was written and still remains the definitive work on Alfred Wallis who died in the workhouse, a pauper, in 1942.

To think back is often painful.

A friend told me he recently went into a gallery in Mayfair and asked the price of the Alfred Wallis painting in the window.

'£8,900,' was the reply. 'We have had several. They sell as soon as they come in! He's very popular.'

Takashi Tanahashi, who is writing about Wallis in Japan, wrote to me: 'Yesterday I visited the Setagaya Art Museum. Some years ago they bought a Wallis, 43.2 cm × 39.4 cm, for 5 million yen.' About £18,500!

When one considers that Wallis was glad to sell his paintings for one shilling he might out-Gogh Van Gogh.

Christies have said the truth: 'The art market determines the prices of a picture—not the artist.' To which I add: The inner value is a matter for the Gods. The reason for this is that he was not doing it for fame or money. He was a simple person who painted because he was lonely after his wife died. He had no more technical equipment than a pot of yacht paint, a cardboard box and a brush. He painted direct like a child. 'I guessed it all!' he said. A true Primitive. He knew nothing of the extra-mural garland cast round his shoulders. He was

completely unconscious of his gift and 'could not do it like those taught in school and paint'. Yet they were gems of complete vision.

When the little grocer round the corner who supplied his cardboard boxes said of him: 'Mister Wallis was always aloof from those interested in his work by what they called his "Queerness"!' this did not mean homosexual as some of my critics have suggested. The connotation of the word 'queer' has changed during fifty years. It used to mean odd, misfit, unusual person, which Wallis certainly was. And a good deal of his oddness would have been self-protection, to make his admirers *hellish*, as peasant folk say. For the Devonian, which Wallis was, the outsiders are called *grockles*, and for the Cornish *foreigners*. His devilment was a way of taking the piss: especially out of the intellectual cognoscenti who visited his cottage.

There will be noticeable changes of meaning in other words which should adjust naturally in the reader's mind, as will tenses and terms of reference.

Wallis came from the river town on the Tamar, Devonport. It is not surprising that another Celt, Sydney Graham, born at Greenock, another river town where ships sailed between the granite landscapes with all the rock formations pointing south west as in Cornwall—also a man of the people who came south in war times as a young poet—should be the one person to see deep into Wallis as a man and as a painter with no trappings about his greatness. When Wallis died it was he who let out the lamentation of profound and mournful beauty:

Worldhauled he's grounded on God's great bank,
Keelheaved to Heaven, waved into boatfilled arms . . .

with all the pride and poverty of an inspired man who spoke with the voice of oceans.

The poem was written for my book, but I don't think he was ever paid: only a copy of the book was sent from London. Nessie Graham wrote to me recently, soon after Sydney had died:

I well remember the richness of those days, the fierce joy the love of everything around us. And I remember the songs by the caravans. But even I had forgotten it was you who asked Sydney to write the poem for your book. And what a great poem your request brought forth.

This puts back into joint the place where the poem belongs, and from where it has been wrenched and separated so often by other writers without asking how the *Voyages of Alfred Wallis* came to be written.

It was Herbert Read who first got my work on Wallis known. I was appalled by his death and wrote an article which Read immediately sent on to *Horizon*, a cultural magazine run by Cyril Connolly and Peter Watson during the war. Ben Nicholson heard about this and at once sent an article of his own to push in front of mine, but the editors insisted on mine going first, which left a splinter

in Ben's finger. I was in uniform when it came out and completely unknown; my article was the target of a really nasty attack by Evelyn Waugh, but was defended by Graham Greene in the next issue. This might seem irrelevant were it not that this was the first writing about Wallis and opened up the whole firework display which has gone on ever since as though I had hit an ammunition dump with a stray rifle bullet.

By then I had just finished the book in the vestry of the Methodist Church at Hitchin where I was stationed. It was Tambimuttu, the Sri Lankan poet of *Poetry London*, who took the initiative and decided it must be published, but because of the shortages in war, and a few shadowy sanctions, it did not appear till 1949, nearly ten years after I had started my research in those golden interiors of the Cornish fisherfolk.

I remember one afternoon in August 1942 before I joined up, meeting Adrian Stokes on the Wharf, which was unusual.

'What on earth are you doing here?' I asked, greeting him.

'Looking for you,' he said. 'Wallis has died and I am his executor, so they have put his body on the train addressed to me at Carbis Bay. I really can't do with him at Little Park Owles!' We were standing outside the Salvation Army headquarters. 'I don't know what to do!'

'Go in there,' I said. 'I know his wife was a devoted member and probably he was. They will fix up the funeral.'

'Well, can you arrange the flowers, Sven? I'll pay for them. It's awfully good of you.' Like Joseph of Arimathea he went nervously into the building, where, although Wallis was a lapsed member, they arranged a decent funeral. Adrian paid £4.10/- extra for a grave that saved Wallis (unlike Mozart) being buried in the paupers' corner. I arranged the flowers with a Mr Anthony who ran a greengrocer's shop in Fore Street and for whom I had worked on the fields.

I did not go to the funeral because I had to go to London to see Tambimuttu about the book. He later tried to get someone to ghost-write it and I was very angry. In the end nothing changed but bad grammar. But Bernard Leach and George Manning-Saunders, the novelist, agreed to stand in for me and report back afterwards, so my account of the funeral in the book is by proxy. Margaret Mellis, at that time Mrs Adrian Stokes, was there and has published an account from her personal diary. Between the two it should be a sound record: although neither Bernard Leach nor the Salvation Army Officer, Clifford Axon, mentioned two funerals on two separate days.

On my first leave from the Army I started a subscription for a stone to mark Wallis's grave. It was Adrian's idea. He wrote:

'I saw Bernard the other day before I got your letter. He didn't say anything. Excellent if he took a hand. You are the Field Marshal in this and must decide about the scheme, whatever it is, and I shall help you put it into operation.'

I asked Barbara Hepworth to carve a stone but she refused. I wanted to do it, a granite figure on that sloping graveyard as though

'towering out of the cupboarding sea . . .'

but it was not to be. Bernard did it in the end. He made the golden lighthouse in large pottery tiles with the inscription:

ALFRED WALLIS
MARINER
INTO THY HANDS O LORD

It took Bernard's unassuming sincerity to realise that Alfred had gone back into the hem of invisibility that held his wife and ancestors, and had made this honest mark where the old mariner had last been seen. When I came to reckon up, Bernard got only about £19 to cover his costs. Few subscribed and none were very generous. But it's there for all time.

A man's work is the sun that lights his eye and transmutes its beauty to our souls, adding a cubit to the stature of man, while he rots into resurrection. When Wallis was given a show at the Penwith Society after his death, prior to one at the Tate Gallery in London, I sent him a telegram:

GOODBYE DEAR GHOST LOVE SVEN.

To which sadly I got no reply. But that is how I knew him—as a dear ghost. A silent ghost who without knowing moved the world. In my book I have written of a fierce man of gentle light and honest intention who was the most misunderstood and most exploited artist of our time. I offer you this as a tablet of stone which is his life as it was found—unaltered.

Sven Berlin
Dorset 1992

9

Preface
(To First Edition)

The grotesque fact of Alfred Wallis' death in Madron Institution on August 29, 1942, crystalizes for those who knew him, and the few people who were inspired or moved by his paintings, both the tragedy and glory of a life that was wholly sincere and valuable from the beginning: the story of a mind of genius endeavouring to grope its way to the light through the darkness of ignorance, extreme economic pressure, and the tyranny of a primitive religion. The way to this freedom he eventually discovered through painting, though not until he was over seventy years of age; he has left for us some of the most *naif* pictures of modern times.

During his painting-life, which lasted approximately from 1925 until his death, he was known by a few people who understood his work; the society in which he lived, save for three or four friends, had rejected him; he in his turn had grown more morose and ascetic as time went on: a logical conclusion to years of starvation of fundamental human needs within himself. He became a hermit.

In his cottage at No. 3, Back Road West, St. Ives, he lived a peculiar life—a life that was almost incredible—for not only was he in a condition of poverty and filth that was a disgrace to human life, but he conversed with spirits and voices which tore at his mind like the furies of Euripides, and spent his nights shouting defiance at their threats, for they were the agents of the Devil who lived in the upper room, working to drag the old man from his belief in the Bible and to destroy him by eternal damnation. With the help of the description given by Mrs. Peters, his next-door neighbour, it is not difficult to imagine how he suffered at these times. Mrs. Peters is a thin, grey-haired woman, with faded eyes: a fisherman's wife. She was very good to Wallis in his last years. She said:

"I allus noo when it was comin' on. I'd be at the door, see, an' 'ed go bye. 'Evenin', Mr. Wallis!' I'd say, but 'e tookt not a bit a notice. Into his house he'd go an' slam the door. I'd say to Mr. Peters: 'Looks as though Mr. Wallis is goin' to have one o' they bad turns!' An' sure nuff he'd be in there shoutin' all the night. Do 'e know, Mister, I've seed him hold his 'ead with 'is two 'ands (like this 'ere) and us faice go dead white, 'n braike out hall over in sweat—sump'n tarrable."

During the periods of these attacks Wallis got little sleep, and in consequence he lay late of a morning on the old couch he had converted into a

bed. Very little painting was done. Between times, however, work was prolific.

There was a cycle of mood, of personality, which had both its driving force and structure in the past. It is this we must piece together to understand him, and follow its progressive revolutions until they carry us on that last and extraordinary voyage of which he has left us a record in the Death Paintings.

To anyone unacquainted with Wallis the little I have so far written will probably have brought one thought to mind: he was mad. Exactly. He was. Another mad artist to be thrust upon the world. Names like Kit Smart, Blake, Van Gogh, flash across the mind. But they are safe; they are legend as well as legion. "This dirty old man in the work-house," as the Relieving Officer said: "Why trouble about him?" But this idea of Wallis' madness was not new. For years the people of St. Ives, with their native dislike of the abnormal, had marked him down as queer in the head, though, in all fairness, I never heard one of them speak of him with emnity—with compassion, amusement or indifference, yes. The artists and collectors who bought his work did not fully understand his conduct, but they were interested primarily in the pictures he painted.

The lack of mental balance is indisputable—the man's mind was gradually destroyed—but an explanation of why he was like this (which I shall endeavour to provide) drives us at once deep into the roots of his life.

Mr. Baughan, who provided Wallis with milk and groceries for nearly twenty years, made a very astute remark:

"Mr. Wallis," he said, "was always held aloof from those who were interested in his work by what *they* called his 'queerness'."

In understanding this "queerness," and, as far as possible, its origins, we come to find a link between the man and his art: come, in fact, to understand these in relation to one another, how they were both parts of one process growing against a social background, as a tree might grow and spread its branches, bear its fruit, before the fresco of a battle scene in a wrecked building. The tree is odd because it has struggled up between the split concrete of old ideas, and has for years been bunched up beneath the surface. What people have looked upon as Wallis' madness, his eccentricities, his "hobby-horses," his "manias" and his "complexes," were in truth an integral part of the whole structure of the man, and, subsequently, of his art. Nor were these angularities of character in any way derived from a wish to show off, as is so common with artists. Wallis was fundamentally a humble man. He wanted nothing more than to live a quiet, respectable life, paying his way with money earned by the honest work of his hands, as befits a man of his station—and to worship God. For the rest, he was content with obscurity. The oddnesses of a truly great man have deeper roots than is generally supposed.

That Wallis suffered in the way he did is not unique: many thousands

11

endure, in helpless resignation, the lot meted out to him; but the fact that in his case the victim happened to be a genius does make it possible to thrust forward the problem of the life behind the living paint, at the same time as presenting the glory of the work he did.

Some will say: "Why trouble? The paintings speak for themselves." True: they do. There is already too much rubbish written on art. That is why I wish to talk mainly about the man.

This book does not set out to be a scholastic biography. Rather is it an attempt to follow the development of a personality over a period of time, in order to show the interplay of forces that went to produce the paintings Wallis left behind. Exploration of his history has been made with this in mind. While there are tracts of his life about which no factual information can be found, despite repeated and painstaking efforts, no finger-post to act as guide in long searches in the registrar's office and the minds of other people, there are periods, on the other hand, about which quite a mass of material has been found, but only some of it used: that is, the events which cast a direct or indirect light on Wallis from one angle or another.

While collecting my notes and writing the early pages of this book I was called up for military service. The major part of the work has been done (during months of intensive training) in billets, tents, Army canteens, hospitals and guard rooms in different parts of the country, and in the vestry of the Methodist Church at Hitchin. Limited time before going overseas has enforced speed (though I trust not carelessness). I therefore beg of my readers two things: patience and understanding, hoping these pages will at least breathe something of the spirit of a man who should not be forgotten.

Thanks are due to those who have helped me in my task: to all those who have so patiently withstood my endless visits to their houses during those hurried days and nights of research, and dipped so generously into their memories to salvage the half-forgotten tokens that were the life-line of my story. Of these I will mention Mr. and Mrs. Jacob Ward, Mr. and Mrs. William Wallis, Mrs. Peters, Mr. Baughan, Mr. Edwards and Mr. Armour, all residents of St. Ives and friends or relatives of Alfred Wallis. I would include among these persons all those I have badgered and worried for facts in the streets, in the houses, in the shops, the chapels and on the fields. Chief among them is my friend Matthew Berriman, to whom I owe much useful information about the fishing community of St. Ives.

Next in order I must thank Adrian Stokes and Ben Nicholson for their interest in my work, for the facts they have given me, and for permission to study their collections of Wallis paintings and letters, and to reproduce specimens here. Nicholson also helped to carry out the choice of reproductions "according to plan" at a time when I was unable to do much myself. H. S. Ede,

in a generous letter from the States, has enabled me to see my pattern more clearly. To him also acknowledgment is due for permission to reproduce from his collection and for the loan of negatives. In this respect I am also grateful to Herbert Read, Helen Sutherland, Barbara Hepworth, Eardley Knollys, David Leach, William Care, and others.

On the photographic side I am thankful to Otto Kalne for co-operation.

The men in my battery who have shown such a lively interest in the growth of my book during the months of writing have been of greater assistance than perhaps they realise.

Miss Peggy Francis took on the labour of typing the MS. in her spare time, and steered me through many a grammatical reef, for which I am extremely grateful; grateful also for assistance and kindness given by Edna and Ceff Elbra.

My friend Bernard Leach has been a constant source of help and encouragement: not the least of his tasks on my behalf was to snatch hours from his busy life to read and criticize the manuscript. He has made many valuable suggestions.

George Manning-Sanders has been justly critical, helping me to clearer thought by discussion. Among others he represented me at Wallis' funeral, and has given me several anecdotes which have been of use.

To the editors of *Horizon* I am grateful for permission to use material from my article *Alfred Wallis* and the article by Ben Nicholson, published in January 1943. Also for the use of photographs.

Lastly I thank Guido Morris for designing the title-page.

Sven Berlin
Strensall Camp. August 1943

The Voyages of Alfred Wallis

Worldhauled, he's grounded on God's great bank,
Keelheaved to Heaven, waved into boatfilled arms,
Falls his homecoming leaving that old sea testament,
Watching the restless land sail rigged alongside
Townful of shallows, gulls on the sailing roofs.
And he's heaved once and for all a high dry packet
Pecked wide by curious years of a ferreting sea,
His poor house blessed by very poverty's religious
Breakwater, his past house hung in foreign galleries
He's that stone sailor towering out of the cupboarding sea
To watch the black boats rigged by a question quietly
Ghost home and ask right out with jackets of oil
The standing white of the crew 'what hellward harbour
Bows down her seawalls to arriving home at last?'

Falls into home his prayerspray. He's there to lie
Seagreat and small, contrary and rare as sand
Sea sheller. Yes falls to me his keptbeating, painted heart.
An Ararat shore, loud limpet stuck to its terror,
Drags home the bible keel from a returning sea
And four black, shouting steerers stationed on movement
Call out arrival over the landgreat houseboat.
The ship of land with birds on seven trees
Calls out farewell like Melville talking down on
Nightfall's devoted barque and the parable whale.
What shipcry falls? The holy families of foam
Fall into wilderness and 'over the jasper sea'.
The gulls wade into silence. What deep seasaint
Whispered this keel out of its element?

W. S. Graham

1

ALFRED WALLIS
BORN AUGUST 18, 1855
THE FALL OF SERVESTERPOOL
NORTH CORNER DEVENPORT
RUSSIAN WAR

In the above text Wallis gives us his origin against an historic background.

When he first went to Mr. Baughan's little shop in 1923 he presented this across the counter on a square of cardboard, with the tacit inference that it was a "certificate of merit," a way of showing the shopkeeper that he trusted him, and was himself a dependable person, things which, to Wallis, were very important. The directness and originality of his approach speaks clearly of the *naif* simplicity of heart with which he engaged life for eighty-seven years: this is the keynote of the paintings—what someone has called his "innocent eye" attitude.

But this is not all. Having learned the date and place of his birth, one is at once struck by the reference to the "Russian War." For a man who was almost entirely illiterate this seems an extraordinary thing with which to link himself, but the explanation is quite simple. At the time of Alfred's birth his father, Charles Wallis, was fighting at the Fall of Sebastopol in the Crimean War. When his son became of age to understand he was proud of this, no doubt, because it symbolized the qualities of a true Englishman who still retained in his heart the spiritual tradition of duty that grew from the roots of the people: something which the modern emphasis on the economic mental concept of world affairs tends to submerge.

Charles Wallis was a master paver, almost certainly a Devonian, though his grandson, William, has a theory that the Wallis family on the father's side was originally part of the Wallis (or Wallace) Clan from the Lowlands of Scotland, come down in the world through drink, but so far no proof of this can be discovered.

It is difficult to fix dates and origins: these people leave few documents behind; one has to trust to living memory a good deal and is often faced with many conflicting facts that cannot be proved. Unfortunately the one reliable source of information of this kind—Alfred's Family Bible, in which his genealogy was faithfully recorded—was sent to the paper salvage depot after his death and could not be retrieved.

From the photograph of Charles reproduced here it is easy to see the kind of

15

man he was. Had he been a Scot one would have at once said "Calvinist!" Certainly a Victorian moralist, a good respectable citizen with a strong sense of his civilian rights; a parent of austere calibre who would instil the laws of God and society into his children in a conscientious way. Also a working man, though we see him here in his best clothes, in appearance rather like a statesman or a village parson of his day. Behind the photograph we can glimpse his hard daily life, making roads and pavements in the district in which he lived.

His wife, Jane Ellis, from the Scilly Isles, died when Alfred was very young; he retained no memory of her.

According to a statement Wallis made to Ben Nicholson he had twelve brothers and sisters, all of these, save one, together with his mother and father, were buried in Devonport Cemetery, but the general opinion of relations now living is that there were only two boys and two girls. The girls emigrated to Australia and were never heard of again. I write on the assumption there were only four children.

After Charles had returned from the Crimea, Jane lived long enough to bear him one more son—also called Charles—then left him to bring up his family alone. He never married again.

They were very poor, and the children, Alfred has said, had to kick out for themselves at an early age. He was nine years old when he made his first trip across the Bay of Biscay in a schooner. Probably in those days this was no unusual thing—it is incredible to think of it now. From the curiously melancholy face of Wallis in later life, and in the light of these few facts, we can get a fairly accurate picture of the boy who started on his quest long before the first processes of mental and physical development had completed themselves.

He was always short in stature—as someone said: "Too short to fall over." In those days he must have been insignificant, possibly thin and pale if his home life had been such penury. A child, one imagines, with the same heavy eyes as the finished man, and very silent, for there had been little chance to extend his dreams in play.

It must be remembered that he had never known the comfort and protection of a mother's love, which for most of us is among the cherished facts of childhood—so much so that in spite of growth to manhood (or perhaps because of it) moments of fear and loneliness bring instinctive desire to return to it. Wallis was always in search of this unreciprocated love, love of which he was starved until he died.

The child of nine setting out on the life of a seaman, the painter who took up his brush at the age of seventy, and the defeated old man who sailed on the Black Barge from Penzance to Avilon, are emblematic of the mystic in search of God. It was a quest of the heart that Wallis was engaged upon.

It is almost certain he never went to school. What little he knew of reading

or writing he taught himself while he was at sea. In those days school was not compulsory: you paid your twopence but did not have to attend, which was probably what happened in Alfred's case. So there was little community life for these children: the two younger sons, of whom we know most, both grew up to be quiet and retiring men.

The religion of Charles and Jane was Church of England. How much this was apparent in the home it is difficult to tell, but judging by the nature of Alfred's mind and character, the time into which he was born, and a study of his father's photograph—also statements by relatives—I should say the Bible was strongly stressed. That both these boys, from early days, suffered from a lack of sexual, economic and mental freedom is certain, and from this both had to find a way out.

For some years Alfred worked on the schooners as cabin boy and cook. He was efficient at his job. Indeed he proved himself capable in everything he set himself to do, both at sea and on land. In spite of his short stature he was wiry and strong. Even in his last years he still retained the nimbleness, speed and surety of balance obtained from life on the schooners. One must remember how hard that life was, what powers of endurance were needed by the seamen of that time; walking the decks, handling the canvas and rigging of a light "fore-and-aft" schooner in a heavy North Atlantic gale called for high physical awareness and courage. Wallis, of course, was an ordinary seaman when he grew older.

Whatever his early upbringing, it is clear that deep within himself, he had a strong security. I believe it was his capacity for love: not only love for human beings, but a love of *life itself*. His paintings prove this so well. However fierce the tempest or fair the wind there is this joy, and a sailor's love for the sea, its ships, their hard smooth sterns, the churning water, the taut ropes and swelling canvas: the grace, dignity and majesty of ships. Any Cornish fisherman will talk of these things vividly, even poetically. No matter what the danger or suffering, it was always the same—for him it was *life*.

In spite of Wallis' loneliness as a young man, and, most likely, his virginity, the years at sea were the happiest of his life: the sea gave him what the land could not, and on it he worked out the ancient drama of the Odyssey.

Later he gave up the deep-sea boats for fishing at Mousehole and Newlyn, making seasonal trips up the east coast to Scotland, but whether this change was sudden or gradual, I don't know. It is confirmed that he made one deep-sea voyage after he was married.

Alfred and his brother Charles had found their way to Penzance, and it is thought that their father came with them, the three living together until the old man died and Charles married.

After his marriage Charles settled down in Penzance, which was a busy sea

17

port at that time, and opened business as a marine rag and bone merchant; he also bought up old fishing boats, renovated them and sent them to sea again. Unfortunately, he was given to heavy drinking—both his health and business suffered in consequence. In his more peaceful moments he pursued the hobby of bird-watching.

The violence of Alfred as well as the contemplative side is shown, by these two habits, to have been also characteristic of Charles, and along with the marked reserve of them both towards their fellows, suggests the pent-up forces that were trying to find a way out. One is constantly pausing to ask of what nature were their sufferings in early childhood, and reflecting on the hard fight for life from day to day, which, along with their religion and native insularity, created austere, independent, if unfulfilled, men.

Apparently Alfred, while still a bachelor, lived with Charles and his family for some time. It was during this period an event occurred which bred a lasting enmity between the two brothers. It may be supposed they were fond of each other, for early economic suffering tends often to bind children together rather than to separate them, though it is not out of place to believe that Alfred, being the elder of the two, nursed a fairly deep-rooted jealousy towards Charles—especially as Charles was now married. Alfred and his sister-in-law, who was also addicted to drink, did not hit it off very well, and he finally left the house after a quarrel with her, resulting from the following incident, which he often talked about as an old man.

There was an uncle (probably an Ellis, on the mother's side) who emigrated to Australia and became captain of a gold mine. Nicholson says it was the odd son of the twelve children supposed to be buried at Devonport who became the captain of the gold mine, having emigrated to South Africa. In the various reports I have collected this is the only one in which South Africa occurs. The relatives particularly are confident that the place was Australia, and the person an uncle. I must accept the weight of this latter evidence. However, he was a very religious person, and as he grew old wished to pass his fortune into worthy hands. Going on the assumption there were only four children, Alfred, being the eldest son of Jane Ellis, was next of kin, and should have been the recipient of the legacy. But it was Charles who was in correspondence with the uncle, and when he was asked of Alfred's whereabouts he wrote back saying he had not heard of his brother for years, though Alfred was living under the same roof. Alfred discovered this and left the house. He never forgave his brother.

"Anyway," Wallis said in later years, referring to Charles and his wife, "after Ellis died *they* never went short n'more." And added: "But I allus do say the Lord punished 'n for it—brother died soon after."

This incident and others, of necessity, must be seen against the final background of Alfred's mind, and what some have called his "persecution

mania"; but whether his version of the story was wholly true or not, there must have been an origin to his estrangement from Charles, for it could hardly be unprovoked, unless we take refuge in an entirely psychological interpretation, which would not be satisfactory.

That there was a rich uncle in Australia is indisputable (for those were days when such things were true) but Charles' son, William, starting from the point at which Alfred's account leaves off, says that his father's name was struck out of the will because Ellis had heard through other channels that he was drinking, and objected to this on religious principle—the money finally going to a Penzance man named Rowe.

Nevertheless, Alfred's bitterness remained till his death: but for this misfortune he would never have had to suffer privation or live with the terror of the workhouse—and, even more dreadful to him, the pauper's grave—always before him.

A further version of the story says that both Alfred and Charles were done out of the legacy (which was £50,000) by Rowe, and at one time Alfred considered getting a lawyer to fight the case for him. But my informant in this instance does not think there was much bad feeling between the brothers, save that Alfred disliked his sister-in-law because of her wayward habits (he being always a total abstainer), and that later when he himself had opened a marine stores in St. Ives, Charles would come over and buy up merchandise in the town, so taking Alfred's business away: they were both selling to the same merchant, Denley, of Penzance.

The outcome of these stories is that, for one reason or another, there was a degree of bad feeling between Alfred and Charles, but Alfred was "in some bitter way" when his brother died: he ordered two cars to take all the St. Ives branch of the family to Penzance for the funeral.

The lines of Charles' and Alfred's lives ran adjacent to one another, and the angle they made was more obtuse than it might at first seem, for they were alike in so many respects, though, as years advanced, the distance between them increased, and, for Alfred if not for his brother, there receded a source of devotion to another human being who was deeply rooted in his own life.

2

During the 1860's, in the little village of Madron, which lies on the hills above Penzance, there lived a family named Ward. Jacob Ward, a gardener's labourer by trade, was born in Okehampton in 1832: an immense man, six feet five inches in his socks; his wife, Susan, on the other hand, was unusually short. This odd couple were a source of amusement when seen singing in the village choir of the Methodist Chapel, or walking arm in arm down the street. "Why," the villagers would remark, "aint they some quaint. She der look just like a jug hanging on a dresser!"

Madron, indeed Cornwall itself, was a remote place in those days, quite untouched by modern civilisation, and the lives of the inhabitants had not changed appreciably in a hundred years, save in the fashion of clothes that filtered through gradually from Penzance. An undisturbed sunlit root of England founded on a tradition that reached back far beyond medieval times to days when Iberians, Goidels and Celts were driven west by invading tribes, settled in these parts, tilled the land and helped to lay the foundation of the Cornish race.

Life in Madron during the mid-nineteenth century was narrow and secluded. One wonders if Jacob and Susan suffered from being "foreigners," for they were both from Devon. Slight as this remark may seem, it is not really so. The idea of the "foreigner" runs deep into the Cornish mind—so much so that even a man from St. Just who comes to live in St. Ives is a "foreigner," and often never shakes it off. In point of fact I am told there is an age-old feud between St. Just and St. Ives, and even to this day the enmity still lives in the hearts of some of the people. Yet, paradoxically it would seem, all the Cornish are related in an intricate family network; are, in fact, one family: hence the famous nick-name for the Cornishman abroad—Cousin Jack.

As already noted, they have grown up from the conquered residue of early Celts who took refuge on the Cornish peninsula. Throughout their history they have lived under the threat of invasion, not only from other tribes but also from the Phoenicians, the Saxons, Romans and Danes—and the gradual infiltration of modern scientific and capitalist civilisation has also been a terror to which they are only now learning to adapt themselves. This fear was bound up with a religious and economic fear, which I will discuss later. For these reasons the Cornish have always been an insular race of people, and their progressive development has been retarded. Therefore we must expect to find a strong gregarious instinct, with intermarriage building up a family system as a means of protection. Alongside this a deep-rooted suspicion of the "foreigner"

(which term may be extended to the abnormal or unusual individual)—even a hatred of him—with yet an interest and curiosity, for the conqueror may bring with him riches and security, and revitalize the race.

This short analysis is made here to give the reader some idea of the nature of the people about which I am writing; later it will also help to serve as a foundation for understanding both Wallis and the society in which he lived, and for whom he spoke in his paintings.

Susan and Jacob were quiet, God-fearing people, who worked hard to keep their family together. Narrow and limited as life in Madron must have been, they found little difficulty in settling down, for they themselves were of peasant origin.

Susan's maiden name was Agland. She was born in the year 1834 at Beer, Seaton, in Devon. By Jacob she had seventeen children, the last being born three months after her husband died in 1872, when she was thirty-eight; only five of these were reared.

As a girl Susan was trained in making Honiton lace, but after she had served her apprenticeship she came to Cornwall to work as servant to the Bolitho family, who have their large estates on the hills near Madron, overlooking Mounts Bay. Jacob, her youngest son, told me of the beautiful lace his mother made, and that on one occasion she had an order to make a lace cap for one of Queen Victoria's children. He remembers sitting on the floor at her side, watching her fingers flash to and fro, in and out of the bobbins over the round deep cushion she held on her knees, making lace to be sent for sale in Penzance to a man named Blamely.

Her husband was buried in Madron Cemetery, and this able woman moved with her family to No. 2, New Street, a turning off Market Jew Street in the centre of Penzance.

Her eldest son, George, born in 1853, at this time about twenty years of age, served as a waiter in Penzance Hotel. His greatest friend was Alfred Wallis, a young seaman of eighteen, who made voyages between Penzance and St. John's, Newfoundland, on the schooners known as the Newfoundland "cod bankers," their cargo being codfish caught off the coast of St. John's.

There is no photograph extant of Wallis at this age, but perhaps the reader will already have formed the picture, suggested by earlier facts, of a lean, short, young man disposed to take life seriously; pale in complexion (though perhaps sunburnt), with black hair and a young straggling moustache; quiet, kind and affectionate, if rather shy and suspicious; not arrogant but proud, with a latent capacity for violence; not without a sense of fun and a *naif* sense of humour; quick, alert, capable, full of energy—but not satisfied; still with the heavy-lidded eyes, the rather melancholy face; given perhaps to the periods of depression and bad temper which, being inturned, cause the apparently

unaccountable "moodiness" of Cornish people. The austerity of his life would have given him a premature integrity; his religious restraint, lack of sexual intercourse and of the many indulgences of adolescence (for there is no indication that he threw in his lot with those seamen who saturate themselves with drink and women after every voyage), held at arm's length the worldliness that might have been his, and preserved the central innocence and purity of outlook that mark his paintings.

There was something priestly about Wallis as well as puritanical.

Though life had taught him to be careful with his money, there were examples of genuine charity—he was not mean in any sense of the word. This instinct for economic security was deeper than his own experience of hardship.

"The peasant's hunger," said Robert Greacen (and it is not out of place to judge Wallis in this context), "is for personal freedom and sexual satisfaction, two fairly reasonable ambitions for a human being to have: he achieves neither."

"Personal freedom" implies economic as well as intellectual freedom; "sexual satisfaction" implies freedom from excessively hard physical work, mental frustration and religious moral tyranny. In short, it would go a good way towards achieving these ambitions if economic freedom were possible, for the peasant would then need religion for its proper use—spiritual contemplation —rather than as a recompense for a body and soul starved of vital human needs: he would be freed from the fear of poverty and the fear of God. The fear of poverty and the fear of God are the same thing at root—that is, the *fear of extinction:* the same ruling emotion that lived in the hearts of these people when they slept in the stone beds of their hut circles thousands of years ago.

In those early times they were not only in danger from other more civilized nations coming in from the sea on three sides, but also from tribes sweeping in from the east and north, across the Tamar or across Bodmin Moors. There were wild animals, the weather, and the contest for daily food, which was all important and still remains so. Lastly there was the tyranny of imagination: that is the warring with dark Inscrutable Force within themselves, the IT that manifested itself in the rock, the thunder, the tempest, the darkness and the falling star—from which source grew the most primitive animism and monotheistic conceptions of God: a god who was jealous and brutal, who had to be appeased, for he could wither their corn or blast their flesh at a single blow.

Men first grew to praise God because they feared him; but grew to love him, to love the earth and the things that grew on it, their ploughs and gear, the sea and the boats they built, because all these things were symbols of *life!* and to love children because they were the creative extension of themselves progressing through the years.

But the fear remained, and throve because of the severity of their lives and the geographical position of their land. In the economic sphere the Saxon, Roman, overlord or "modern boss" were and are psychologically concomitant with the manifestations of that earlier Force. The wrath of the God of Adam is the wrath of the chthonic God of primitive times who could save or damn them. And because of this suffering there grew up the need for what I have termed elsewhere an impossible secular paradise (which, if we are honest with ourselves, is probably the need of us all, whether Utopian, political, religious or philosophic). This was offered to the Cornish in the worship of Jesus: He is to be their liberator, the answer to their starved souls; He will come again and a reign of glory shall begin.

Wesley's concept of Christianity was particularly acceptable to the Cornish because it united a stern moral discipline with a very emotional form of worship, one which enabled them to release their energies and yet live moral lives, bearing their lot of hardship and poverty without incurring the wrath of the Old Testament God, who is included in their belief and still rules by fear—comparison with Calvinist Scotland and Catholic Ireland can be made here.

Religion in Cornwall is split into a hundred sects: Primitive Methodist, Baptist, Jehovah's Witness, Plymouth Brother, Four-Square Gospel, Salvation Army, and so on; often these groups are split again within themselves; but as far as I can understand them, waiving distinctions, the common principle is based on a powerful emotional belief in the Old Testament, the Revelation of St. John, and a fear of God, coupled with a strict moral observance, salvation coming through the Second Advent of Jesus Christ to the true believer.

Out of this concept the Cornish have made for themselves a workable spiritual diagram: out of their land and sea they have found a way of livelihood in mining, fishing and farming, set on a family basis—one whole structure representing the religious and economic poles: fear of God and the love of life, each interacting with the other and both born from a common root, helping to settle the conflict in the peasant's mind set up by a heart and body starved of rest, food, security, and sexual satisfaction, and fraught with fear.

In Cornwall, among the fishermen, miners and farm labourers, individuals were usually very religious or they were drunkards, though, of course, there was always the devout man who got drunk, the drunkard who went to chapel and the man who did neither. Drink was another recompense for insecurity and often a reaction from religion.

It is perhaps as well to say here that I do not look lightly on the question of religion, or turn a sceptical eye on men and women who claim to have had spiritual experience in various denominations (or outside them) in every age. I believe such experience, in different degrees, may emerge from quite primitive

conceptions of God. But this belongs to a deeper layer of consciousness than I am dealing with now. At present I am concerned with the psychological problems of a race of people, as I have come to know them at first hand, in order to explain, as well as I am able, the personality of Alfred Wallis, whom, I believe, was bred out of this race as a rare and unexpected expression of itself, just as a tree, growing on an open moorland over steep cliffs, might throw off a single blossom but once in a hundred years.

I am convinced that Wallis was concerned with this deeper layer of consciousness, and I shall deal with it later on.

In view of what has been said it is not strange that the one dread of a Cornishman's life is to die in the workhouse and be buried in a pauper's grave, for this symbolizes the triumph of the Inscrutable Force over his primitive ancestors; it brings shame upon them all because of their pride in winning a place in life, keeping a social footing, however humble, and being respected. The Dark House is for the downtrodden and the conquered.

I would venture to say that this fear of the workhouse is not only the Cornish peasants' dread—it is in most of us, though many never experience enough want to realise it. In the early days of insurance policies during the last century, people of York were known to starve so that they could keep up their death insurance and save themselves from the common grave. One day, after Wallis' death, I was in his cottage talking to Mr. Care (the owner) who was demolishing the fireplace before building a new one. We had been discussing Wallis and this had led on to the means of living in general. I remember there was a pause in the conversation, then Mr. Care said, his lean figure squatting down as he chipped away the bricks from the fireplace, where so often the spirits had come from at night to torment the old man: " 'Tis fear. You're 'fraid, see, 'fraid of want—that's what drives a man to be a bloody capitalist."

The workhouse is a springboard to power; every human soul that enters it affirms the security of those more fortunate (or less scrupulous) at the other end of the pole. This fear of which I have been speaking reaches from the primitive hut circle to the doors of the Bank of England, and it is at the doors of the Bank of England that we are prone to shed our shoes of devotion, both to the human cause and to God.

And so men continue to tread on each other's faces and have wars. Fascism is no more than this. Fascism was bred by Capitalism, and is breeding itself again, while underneath the passive, self-destructive, inhibited, tortured peasant toils his way to the workhouse.

It was with these inbred fears, behind and before him, that young Wallis stood on the threshold of life when he met George Ward.

3

The friendship lasted until George died in 1896 at the age of forty-three. In its earlier years particularly it must have been a great boon to Wallis, for it led him to the exact comfort and environment he was seeking.

In the light of later events it is safe to suppose that between his trips to Newfoundland he spent a good deal of his time at the Wards' house, even that he lodged there. Mrs. Ward, it will be remembered, had five children, and only one of them earning. Her husband would have had little opportunity to save against his death, working as he had for the wages of a garden labourer, which were very low in those days. Susan herself was by no means old enough to receive a pension, and as far as it is known she had only her lace-making as a source of income. With a house the size of No. 2, New Street it is more than likely that she took in lodgers, and besides the "summer visitors," who would be more likely than young Alfred Wallis?

The kind of family life he entered into was familiar all over Cornwall. Mrs. Ward, still at this time a Primitive Methodist, worked from early morning till late at night to keep her family alive; no doubt she added a good share to the lines of washing that flash and flounder in the Cornish sunlight of a Monday morning, baked many a pasty in her black highly-polished range, ironed and scrubbed, still finding time to work at her bobbins and attend chapel regularly on Sunday—complete mistress of herself and the little world she governed. Hard, no doubt, as life must needs have made her, motherly and kind, a disciplinarian, a very alive "extraverted" type of woman, much loved by her fellows. In many ways her life must have been complete, even though it was so insecure, for she seems to have had an inward personal security strong enough to act at all times as a foundation for daily life. Whatever may be said of these peasant people and their primitive religion, it is certain that every principle they hold is tried, proved and made *real* for them by its application to daily life.

The loneliest part of Susan's life at this time was in the fact that she had no bedfellow and confidant. In childhood she had been brought up without parents, and, like Alfred, had had a lonely, severe youth. After serving her apprenticeship it is only to be expected that this short Devon lass should be attracted by the giant of a man she married. They would appear to have been admirably suited. Probably they came to Cornwall together to take a joint job in service to the Bolithos—but one can only surmise. So despite her having had seventeen children, and buried twelve, before she was thirty-eight, Susan had got something from life. But her needs now were not only for a bedfellow and confidant but also for a breadwinner.

In 1875 George Ward was twenty-two, Albert twelve (then beginning his apprenticeship with Mr. Nichols the baker at the top of New Street), Emily eleven, Jessie six, and Jacob three—a young enough family with a corresponding amount of fun and energy (though Cornish children are curiously serious about life). Emily would be helping in the house with washing up and so forth, Jessie probably making her first essay in mother-hood by looking after Jacob.

Supposing for a moment that Alfred Wallis was the youngest but one of thirteen children, in view of his brief home life it is hardly likely that he got much enrichment from their company, especially as he was so repressed. But the Ward children, save George, were all his juniors. Moreover he was a man with the beginnings of fatherhood stirring in him. He needed brothers and sisters, he needed children of his own—but also he needed a wife and a mother. A curious mid-way situation in which to be.

Entering this home he was comforted, for he was completely homeless. Susan's large maternal instinct soon wrapped him round, held his divided nature together and made him whole. He became one of them, and from the eldest down to little three-year-old Jacob they called him "Alfred." Even his religious bent and his short stature were in key with Susan. It is only logical that he should have married her, in spite of the fact that she was twenty-one years his senior—or largely because of it.

One can imagine how at this time the strain of loneliness, of spiritual and sexual starvation, fell away as his heart and body were satisfied.

That Susan was at least partly aware of their relationship is shown in this anecdote: In later years the eldest daughter, Emily, said to her mother one day (referring to Alfred): "Why, Ma, he's ony a little boy! I do believe you tookt 'en in!"

"That I did," replied Susan, good naturedly, in her rich Devon accent. "I tookt 'en in an giv'd 'en a home, an' 'e were a *good* boy. 'E worked *'ard* and made a livin'—an' 'e reared *you*, me dear!"

Alfred did work hard, and continuously so, for he had six dependants.

For at least another two years he must have kept on the Newfoundland boats. This life was particularly arduous. Sometimes in rough weather they were blown as far out of their course as South America, taking thirteen weeks to get home.

The boats were light fore-and-aft schooners weighing 150 tons. The *Dolphin*, a Penzance boat, was one of those on which Alfred worked. Also there were two running from Newlyn, owned by a man called Beasly—these were the *Alpha* and *Omega*. From St. John's they took their cargoes across to Leghorn and Genoa, or straight over to Grimsby. A record run from St. John's in fair weather was thirteen days.

I think Alfred Wallis' deepest emotional experience was gained during these

years at sea: nearly all the earlier paintings are parallel with this period, and among the most powerful things he did. His thought was under development. As the schooner sliced its way swiftly through the sea, like sledge-runner through snow, he was aware of the whole behaviour of the boat as keenly as though it were part of his own body. Steering by the stars at night in an arctic breeze, and suddenly seeing an iceberg loom up in the moonlight, like a movement from Sibelius, of which his paintings so often remind one, was a part of his experience. For such a nature, out in mid-ocean, so close to the primal feelings of mankind, and with very profound convictions about God, it was as if he moved near to the "face that moved upon the waters," understanding Him not as the written word but as a soul questing for understanding. In the sea, the ship he steered and the vault of heaven, were manifest the elemental qualities which both kept him alive and gave him a sense of the eternal and marvellous nature of the universe, quite apart from his own belief in the Bible—or rather, as the reality of the spirit that moved behind the word that was written. Of the Book he so loved he often said: "This is my chart to Heaven!"

So one comes to understand the dignity and character of the fine architectural proportions he gave the schooner in full sail cruising out of the harbour into the blue sea, painted on the surface of his work table—we understand also the joy and seriousness. It was this deeply religious attitude to *life itself* that was the source not only of the content of his paintings but also the faultless intuitive instinct that governed the nature and organization of their inherent artistic and aesthetic qualities, and enabled him to paint surpassingly beautiful pictures without the least knowledge of accepted technique.

It is this inmost centre of the man, the spiritual core, that coiled during his long life to find a way through the entanglements of his mind: economic responsibility, religious and moral fear, sexual starvation; paradoxically, these very things which acted as obstructions constituted a diagram or pattern that in turn acted as a discipline to the realization of this larger self, setting up a conflict in which the terrestial self was finally destroyed.

The awakening of this deeper self may have occurred at a very early age—one cannot tell—but it was continually fluctuating and giving place to the other forces at work. The emergence of this "mystic consciousness" is gradual: it is a battle in which both sides tire and subside, rise again in conflict, achieve major and minor victories, during a long course of destruction and immolation. Within the human personality, as within the race, when the spirit of Truth is revealed, whether in Buddha Gaya, Karbila, Bethlehem, Athens, Lambeth or St. Ives, there is set up a tension of forces which have to find a reconciliation.

I am not claiming for Wallis that he was a great prophet or luminary, but I

27

wish to point out that, as with all good artists, he was in touch with the level of consciousness which, in men of greater spiritual stature than he, was the source of their illumination and the cause of our adoration. This is based on a belief that life, in its process of becoming, breeds such personalities from a race, a nation, a tribe or local society, as a means of revealing some aspect of Universal Truth, and of the hierarchy of eternal values. These revelations may take the form of an abstract construction in space, a system of philosophy, a sonata, a building, a painted picture, a poem, a pot, the spoken word or the personal presence—in fact the forms created for this purpose by the human intellect and heart are multitudinous, and stand at different levels of achievement or failure on the sliding scale of life. When the spirit speaks through a painted picture in forms of beauty wedded to a content of profound feeling we recognize what we may term our *human genius*—which is an expression of this deeper layer of consciousness. A man in whom the channels are open sufficiently for this quality to emanate in one form or another is called a *genius*, and it is in this context I use the word in regard to Wallis.

The communion of a man with his primal source, whether he achieve it like Utamaro by visits to the Yoshiwara, like De Quincey through opium, like Eliot through contemplation of sacred mysteries as symbolized in the Church, is the act of truly religious experience, as distinct from the psychological escape and emotional release of a man or woman in religious or artistic ceremony of any kind.

I wish the reader to bear in mind these two definitions while he is reading the chapters that follow, for the word *genius* has become so mishandled as to become almost meaningless, and the uses of religion and art, save for a few, have been almost forgotten. One cannot say this is their only use, but among the important functions they have, that of expressing or holding communion with eternal values is a primary one.

In smoothing out the crumpled document of Wallis' life so that it reads clearly, one is led unavoidably into generalizations that may only be partly, and certainly only relatively, true. But the task cannot be achieved without a little supposition, a few speculative statements about the universe, the working of man's curious soul and the purpose of life. When the bricks and mortar are in place, the scaffold may be taken down.

"Nothing in this world is single," least of all the parts of our human personality in relationship to one another and to the intricate pattern of the outside world. Our problem, both spiritual and political, is concerned with an enormous geography of parts, which is never quite the same for any two people, for the pattern is "new in every moment." No doubt we move towards a complete conciliation between them—as it would seem a few individuals have succeeded in doing at different points in history.

So, in fact, although Wallis' voyages across the Atlantic may symbolize his questing soul, they were at the same time his questing body. He went to Newfoundland to earn a living and keep his family—the material, creative aspect of the process that perpetuates the race. And besides becoming an Ulysses, he had become also an Oedipus, and the seeds of a curious destiny were sown. The contest between these two lines of forces is vividly symbolized in the story he often told when an old man.

The crews of two boats stood on the quay at St. John's, one wishing farewell to the other, who were taking their schooner back to England a day before the crew to which Wallis belonged. The day was fine and the weather fair. "We'll see 'ee in England," they said, "God speed to 'ee!" and waved them out of sight. But that boat never saw home again; it ran into a heavy gale and all hands were lost. But those who stayed behind knew nothing of this disaster. On the following day they set out at the appointed time and themselves ran into the same weather in mid-Atlantic. It is only necessary to turn the pages of Conrad to get some idea of what such an experience meant. It left a deep impression on Wallis. The men fought to the last ounce of energy and endurance, only saving themselves by making a chain and passing the cargo of dead fish up from the hold through the hatchway, one to the other across the deck and throwing it into the sea, so giving the boat an opportunity to right herself and cease labouring. They were driven a long way out of their course and were late home.

In the meantime Susan, who was expecting a child by Alfred, waited anxiously. Finally the report came through that his boat was lost. The child was born, but whether prematurely or not is unknown. But the shock to Susan (coupled with the fact that she had already had so many children) resulted in its death a few months later.

This is the last link we have with Alfred's deep-sea voyages until he began to paint some fifty years later. It is probably about this date, which can be roughly fixed as 1880, that he gave up the schooners for local fishing at Mousehole and Newlyn.

Later on another child was born (both Susan's children by Alfred were girls) but died of convulsions in infancy. Susan's child-bearing days were over, but her spirit remained ever willing even though her body had become unfit for this hard job in life. When someone remarked upon the number of children she had had, she replied gaily: "Yes. An' I'd 'ave another to make a score, an' get a letter from the King!"

But she had her twentieth—it was Alfred. . . .

One feels, and perhaps rightly, that the death of these children was far more of a tragedy to Alfred than to Susan, for they were the only ones in this large family he had entered who were his own. (It is significant that they were both girls.) And now, having been denied the place of father in this life, he had to

content himself by working the part out in fantasy with the step-children, the eldest of whom was two years his senior. His wife was now moving through the time of life that would make further opportunity of having children impossible. Besides this her need for physical satisfaction would be waning, while Alfred was still a young man in no way fully awakened sexually.

In marrying Susan he had, at least temporarily and partly, filled his need for a mother; but being in this relationship it was possible for her to dominate him—which she undoubtedly did—and over a number of years he stored up a great deal of bitterness because of it. Besides which (and again because of it) he had cut off once and for all the opportunity of experiencing the burning ecstasy of a reciprocated love for a young woman, with its crescendo of physical union. This desire was yet one more thing in his nature that had to be repressed. The pressure must sometimes have been terrific; but when it is remembered that, deep down below the surface, this "other" layer of consciousness was pressing up towards the light, we no longer marvel at the violence of some of the paintings.

The images he chose both in painting and drawing continually remind us of the two inward forces, pressing downward and upward respectively, only finding freedom in the love of the sea.

Turning to the table painting again we see, on each side of the marvellous schooner, two lighthouses: on the top right-hand side a large fat white lighthouse growing from fertile green grass—this is unmistakably phallic (though it is interesting to note the black cross, which is both female and celestial). On the lower left-hand corner there is a thin dark-brown lighthouse set on rock, with a light radiating from its apex like a halo. It is both celestial and female, the truly religious symbol of the soul waiting in patient humility, and at the same time the light that guides the seafarer. Strictly speaking there is only one lighthouse in Wallis' paintings, which continually changes its significance as the cycle of his personality is newly described and his life moves forward: the essential reality is the schooner plunging seaward between these opposing symbols.

It is well known that racial imagery is common to us all and cannot be avoided; in its use we unconsciously reveal our inmost natures. Anthropologists explain very clearly how all religious imagery has its origins in this deep racial consciousness and is originally sexual. But as forces are released, reorganized and reorientated, our energies are sublimated to a higher plane. In following the evolution of Wallis' lighthouse from the beginnings until it reaches the final elongated aspiring form of a Gothic spire in the *Death Paintings*, we have, as it were, a finger-post to tell us the way he has gone, and can read from it, with other co-related symbols, how his mind was functioning at that time.

It is only necessary to look at a batch of his paintings, or even one of the

30

sketch-books he filled in the workhouse during the last year of his life, to see how persistently these things forced their way to the surface. Some of the paintings are more erotic than others; early paintings are noticeably free from eroticism, but as he advances through those last seventeen painful years, in which he relived and re-created the entire pattern of his life, it continually recurs. The harbour scene done in 1932 is illustrative of my point. The bird-forms of the sketch books change from male to female—the emphasis on steering wheels of boats in some of these drawings certainly marks the fertility symbol. Boats themselves more than anything. And one is often aware of the vast "oceanic" feeling of Motherhood—as well as that of eternity and of the sea itself.

We could carry such analysis to an extreme and read some erotic context into everything, but to say the least it would be very unwise, and not at all true. To do so, only in a small degree, is not to condemn the work. Some of these paintings are very beautiful and full of the texture of his mariner's dream. But it is necessary to indicate the several forces that were working through him, in coming to understand the man and his work. The fact is that the images move and change so beautifully through the aesthetic, economic, sexual and religious spheres that one cannot always determine on which plane he was working, for the planes themselves are shifting, intersecting platforms of light that foil our perception of the point of division—"to apprehend the point of intersection of the timeless with time is an occupation for the saint."

An artist at best only stammers his message, and when we consider Wallis, it is only the more marvellous that he managed to tell us so much about himself, about the mystery of life and the superlative architecture of the universe.

In trying to explain why a man paints one sets about a seemingly unanswerable problem. When the psychological and economic analyses are made, when the religious attitude has been clarified (and, in the case of more scientific writers, the biological situation), it seems we are no nearer revelation: there are such simple things we do and observe that remain a mystery. And then a prince will turn monk and alter half the world; an old man will starve in Bloomsbury and change a continent; a bricklayer will become an Alexander. Why then is it so extraordinary for an unknown mariner to paint good pictures? If he had had a normal life, lived a reasonably hard but secure career, married a fresh, full-blooded girl and had children, would he have even needed to paint? And if he had not by chance or destiny gone to live in St. Ives and found himself alone in old age in an artists' colony, would he have ever thought of expressing his need in this way? It is difficult to say. I think probably not. But one can't be certain. Art is such a curious manifestation of the human spirit. But presupposing different conditions and environment, he would most likely have been like any other fisherman in Cornwall, walking the quay and expressing his vivid poetry by word of mouth.

For all that one still has the inmost centre to deal with, and it is only on this hypothesis I can hope to throw some light on the problem posed. It seems to me that Browning's words speak a truth: this centre is common to all human beings. In many it is overlaid: "Wall upon wall the gross flesh hems it in, this perfect clear perception—which is truth." In some the spark is perhaps stronger than in others: in many lives it scarcely glimmers, while in others it radiates with an almost celestial light. I identify it with what has been termed the mystic or transcendental consciousness already referred to. It stands to reason that the manifestation of this in a personality living in modern times is going to make things difficult, and will even condition the circumstances which so often accompany it and may seem (perhaps are to some extent) the cause of it coming into our field of vision—at least they help to choose and make the form through which it is expressed, be they hard or luxurious.

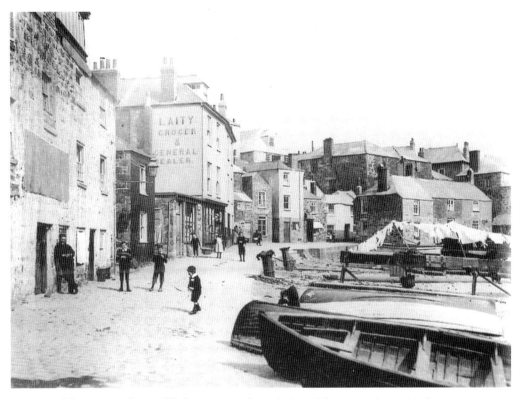

1. The St.Ives that Wallis knew: Wharf Road viewed from Quick's sail loft c.1900.

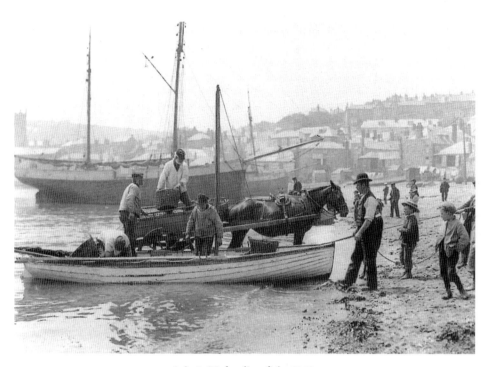

2 & 3. Unloading fish, 1903.

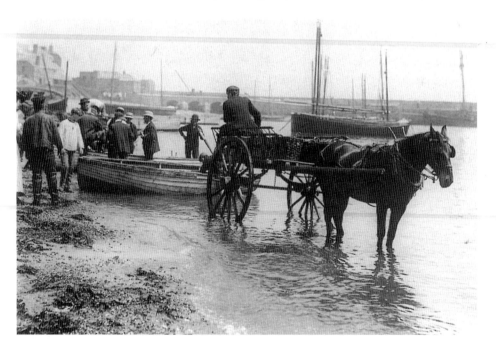

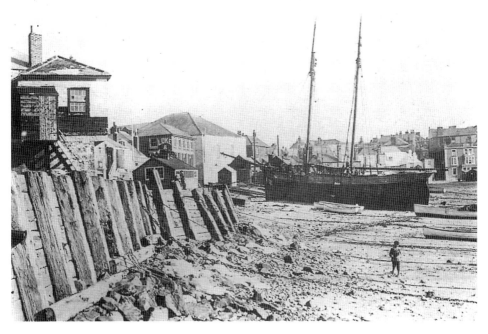

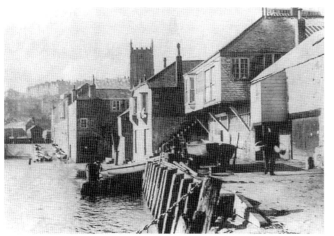

4 & 5. 'From old
photographs, it is
possible to gain some
idea of the wharf as it
was . . . the broken
rocks over which the
waves beat right up to
the houses.'

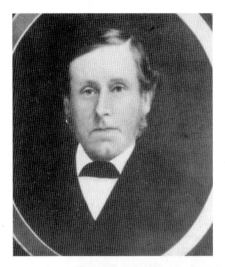

6 & 7. Alfred's father, Charles Wallis, undoubtedly a good respectable citizen, and below, Alfred's 'curiously melancholy face'.

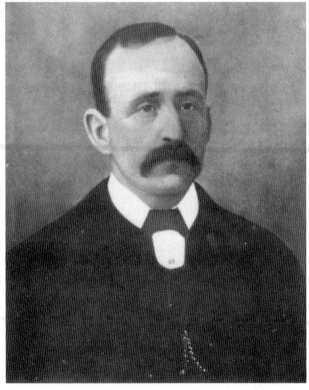

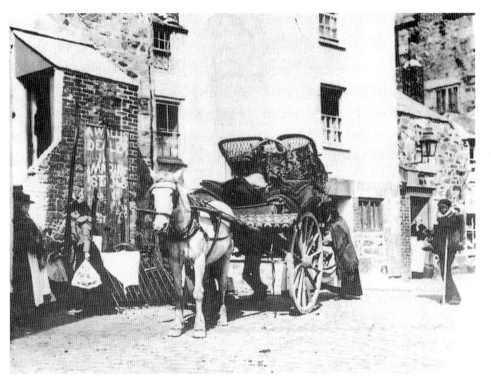

8. Alfred's rag-and-bone business.

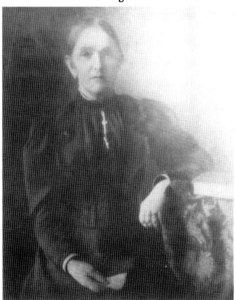

9. Susan Agland, 21 years Alfred's senior, was surrogate mother as well as wife.

10. Another photograph of the Wallis business, with Susan looking out. The
postcard publishers saw this as a 'quaint corner', with children posed to add local
colour.

11-13. The house in Back Road West, where Alfred (pictured c.1938) started painting after his wife's death, and where he developed his persecution mania.

alfred Wallis
Thron under moter Car
stoned down ligven hill
Boys sent in a Train from
Penzance Boys Brought in
a sundays Serves
Boys in my Truck By The codd guard
and out To Cart hw
and around my house
and other places
Boys esent around The hous.
To Throw istones in The houst
as i opened The door one passed
over my hade in The Kittn

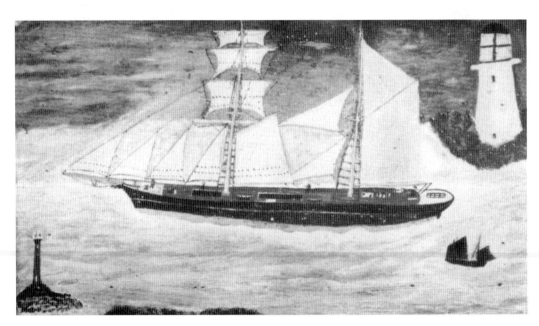

14. Table painting.

4

Of Alfred Wallis' days as a fisherman at Newlyn and Mousehole very little is known. He worked on a boat called the *Flying Scud* and made seasonal trips up the east coast of England to Scotland.

Mackerel—March to June.

Herring—October to Christmas.

The boats were sailing craft at that time, engines not being introduced till much later. But during a good season the fishermen, working on a share basis, did moderately well. The life was hard and not without its dangers; nevertheless, they loved it, for it was a part of them.

Alfred would have lived like the rest of the community, mending nets, preparing and painting the boats and buoys, dressing his oilskins and great leather thigh-boots they wore in those days, in readiness for each season. If fishing locally, one would have seen him pacing up and down the quay, only a few steps each way (a habit formed by pacing the small decks of the fishing boats to keep warm at night while watching the nets), waiting for the tide with two or three others, discussing the things of the day. No doubt Susan's hands were kept busy with the nets sometimes, and with making a new "oiler" out of canvas, which had to be dipped in a cauldron of boiling oil and hung out to dry before becoming ready for use.

These people are industrious and practical; they are (or were before the community began to break up) self-supporting and self-contained. They did not like interference from outside, and resented anything new or novel—partly because of their past history and corresponding make up, partly because they sensed in progress and invention the enemy that would finally vanquish them. They clung to their little medieval world, loving their trade, the forms and feel of the tools they handled, shape and colour of the boats they built with their own hands, and the seas upon which they sailed—the only strong cleavage within their group being the two tendencies already mentioned: towards drink and religion—but basically they were held together by their root. Short, strong-boned men, with square faces and blue or hazel eyes, with now and then a dark Iberian type among them. Their job was fishing, and they kept to it. Suspicious and wary of any strange face, the mob spirit always near the surface.

There was a riot in Newlyn which revealed this side of their character very clearly. The Lowestoft fleet was in for the pilchard season, and caused such a stir in the locality by going out fishing on Sunday that the Newlyn men rioted. A rope was tied across the mouth of the harbour; when the boats came in the Lowestoft crews were beaten up and their fish thrown back in the sea. The

feeling rose so high that the Penzance men formed gangs with truncheons to protect the men from Lowestoft. Finally a battalion of soldiers was drafted in and during every pilchard season for some years afterwards (so the story goes) a man-o'-war was anchored outside the harbour.

This incident, symbolizing the terror of the ancestral curse, is one of many that have occurred—even in recent times—and serves well to show us the strong feelings that lie just below the surface of these peaceful little fishing communities.

But among themselves they are vital, and, in their own *naif* way, humorous, kind and generous, and as I have said earlier, vividly poetic.

It is for these fishermen, as well as for the deep-sea mariner, that Alfred Wallis speaks. He gives us the spirit of their lives, in and about the harbour, as well as at sea, even to the ultimate destiny of many of them—the workhouse.

Wallis' naïveté is not something just personal to himself; it is characteristic of the people he grew from. He painted, one might say, as they speak, and as he himself spoke, in the very way they feel and think. It is always a mystery to me that they never understood him as a painter ("h'artist" or "drawer," as they would say), but broadly speaking they have no art of their own by which they could judge him, and were already conditioned by the academic paintings of Newlyn and St. Ives; though why they should ever have accepted these is unaccountable, for so far only a few of these artists have properly understood the things they have painted. They have diverted our vision of an austere and simple people, and the people's own vision of themselves, by throwing a self-conscious image from their palettes. It is a good thing that Wallis was never able to master their technical methods, for it is doubtful whether his mind would have been powerful enough to throw them off again, and he would have become just like any of his local contemporaries.

It is not surprising that the one artist we now know the Cornish fisher-folk to have produced was a painter—not a writer or musician. Apart from the fact that writing and music require a considerable degree of education (except in the case of peasant folk songs and dances), the fundamental Cornish attitude towards external events is one of visual form—as it is with children. They use their eyes continuously in their work: navigating, they become intimately acquainted with the character of the coastal landscape, and, to some extent, the heavens; the sea they know in every fluctuating mood—its essential nature and behaviour become part of them, its every change of colour speaks a language, telling them of the whereabouts of fish (mackerel and pilchards, for instance, "make their own water"). But only *essential* qualities are registered— and it is in these their sense of beauty is inherent—all superficial, diaphanous aspects being rejected. In the handling, sailing and maintenance of their boats, they have come to understand not only what a boat looks like under any

conditions of weather, but also what it feels like to be *in* the boat under those conditions, moving between calm and storm, or lying in harbour. Every sinew of their bodies is tuned to each movement in this long scale of experience. Rhythms, the intersection of lines and tensions, the structure of forces are all part of this.

Handling tools, fish, ropes, spars, nets, masts and sails, they have developed a real sense of form and texture, of roundness, smoothness, hardness, wetness, angularity, roughness and so on. Preparing and sailing their boats has taught them the need of method and organization in the arrangement of objects—which to them, because of their visual awareness, have a definite and *right form*, according to use, weather and the results needed. If a mizzen sail is not set correctly the boat will not keep its bows to windward when drifting for pilchards, so the angles of both the mast and the mizzen must be right; if the sail is not prepared properly, stained to a beautiful dark brown with bark or ketch, it will perish, or, under a sudden wind, get torn. This is only a minor example of the marvellously logical arrangement of forms and colours in a fisherman's life, given here to show how his mind develops an understanding of the elemental structure and behaviour of objects under varying conditions, and the way in which he has come to see these objects organically, as forms, colours and tensions existing in their own right, as well as in a representative and functional context.

Out of this grows an aesthetic, which is largely the aesthetic of Alfred Wallis. *His* art school had been the Atlantic Ocean and the rugged coast of Cornwall.

In the last chapter I have said that Wallis' religious attitude to life (the term "religious" being defined as unity with the deepest springs of life both within himself and the universe) was the source of the content of his paintings and the faultless intuitive instinct that governed their inherent aesthetic qualities and enabled him to paint good pictures without any knowledge of technique. Superficially, it may seem that I have made a contradiction, but it is not so. In earlier pages I have endeavoured to explain how intimately the economic and religious problems are married, and subsequently how, out of this, the gaining of material and of spiritual nourishment have grown to be one and the same thing: two sides of the coin of daily life. That the spirit of life moving through them should make itself manifest in their experience of their boats and the sea is the logical result.

If the functioning of this mechanism had been secure and infallible they would have been vastly more happy, but they were still at the mercy of that other Inscrutable Force, that may come in the form of a "cloud no bigger than a man's hand," or a steam trawler from Grimsby, and their fears were kept alive, driving a wedge deep into their souls and dividing them.

In Wallis' case we have besides this the psychological complications arising from his marriage, all of which drove him to seek economic security on the one hand and salvation through a Primitive Orthodox Religion on the other.

In 1890, Mr. Denley of Penzance to whom Charles Wallis had been selling the merchandise from his marine rag-and-bone stores, asked Alfred to go to St. Ives and open a business of the same kind.

From what I gather, Denley was a hard business man, short in stature and shabby in appearance. He wore the same clothes "Sundays and Mondays." On a Sunday morning he would be found on the harbour looking "as miserable as sin," his long unkempt hair hanging down over a dirty collar. It is said that he died leaving £500,000.

Alfred accepted the offer and moved his family to St. Ives. He was then thirty-five and Susan fifty-six.

5

Denley knew what he was doing: in 1890 St. Ives was the centre and home of a thriving industry—the fishing community was at its most prosperous. The little harbour was packed with boats "tier upon tier," and the Porthminster Beach, adjacent to the harbour, was then the home of the seineing boats, which were concerned entirely with pilchard fishing. It is now given over to holiday-makers.

From old photographs it is possible to gain some idea of the wharf as it was at that time. In contrast with the present sea-wall and promenade one is struck by the broken rocks over which the waves beat right up to the houses.

When Wallis first came to St. Ives he took up residence and opened his business in a tall house on a part of the front called Market Strand. From his windows he would have looked out straight over the harbour and commanded a view of the whole of St. Ives Bay, which he painted so often and so well.

The town sits in a hook of land near the toe of England on the north side of Cornwall, protected to the west and south-west by the rock-strewn hills of Zennor—Trevalgan, Trevega, Trevessa, Treloske, Trem Crom—names that contain the utterance of early man. They grow out of a wide moorland covered with fern root, gorse and wild heather. A place where the spirit of Cornwall is preserved as a primitive and living thing, drifting up in the rain-mist, moving in the sparkling dust of many sunsets, sliding over the seals that swim among the rocks, stenching in the fox, brooding over the

> figure on a hill, whose spirit
> Is a wet sack flapping about the knees of time.

The town itself has not changed much during the first half of the twentieth century. The same stone houses are grouped about the brown church tower, channelled between by narrow cobbled streets, busy with daily life and silenced by the petrifying moon. Only the council houses on the steep hillside that lifts from the centre of the town to the edge of the moors are out of conformity, standing for the wedge that split off the industrial life from the people, and brought poverty and bitterness among the fisher-folk who dwell round the harbour. They are an explanation of how the Cornish were finally invaded.

I have been able to find out very little about Wallis' life at Market Strand. His youngest step-son, Jacob Ward, is able to tell me little more than that he remembers, when the sea was rough, exit from the house was impossible, and he had to stay home from school.

But it was not long before they moved to No. 4, Bethesda Hill, a steep narrow alley running up behind the western end of the harbour. It was here the

business got well founded and Wallis became part of the town and its life.

The new home was a four-roomed cottage of brown granite with steps and a twisted iron railing running up to the front door, next to which was a large cellar where he carried on his business.

A little above the cellar is a court called Bethesda Place, where the Bryant family lived. Mrs. Jacob Ward, formerly a Miss Bryant, remembers saying to her mother, Ellen: "Why, Ma, do 'e *know* who is comin' to live nex' door?—a *rag* and *bone* merchant!" Her mother gasped. A few days after Wallis had moved in Ellen met Susan on the steps at the bottom of Bethesda Hill. Both rather stiff and straight-laced, with the little brown houses crowding round them. Ellen stared at Susan, greeting her coldly. Susan returned the greeting with a little more geniality and after a pause said: "I think I'm going to like you!"

Ellen drew herself up.

"*Really*. Well 'e may find yourself mistaken. 'E shouldn't say things like that to people 'til 'e known 'en better!"

This parted them.

When Ellen got home she told her father what had happened.

"Do 'e know, Da, she says she goin' to *like me*—s'forward!"

Da looked at her gravely, and when the silence which age commands had been given, he said:

"Ellen, m'girl, that woman der stand in the heyes a' God."

Alfred and Da became great friends, until the death of Da, which occurred under rather sudden and tragic circumstances. He used always to say of Alfred: "I *like* that little man!"

Susan and Ellen also became friends.

Whenever the voices of the strolling street singers were heard outside Ellen was known among the neighbours for running at once to her cellar to make tea. "You've only to hear they singers an' Ellen's kittle goes h'on!" they said. Susan was soon known for this same act of charity—often the singers were asked in and given food.

As time went on the business began to grow. Alfred worked extremely hard, turning his hand to anything that would make money honourably. He was, in fact, the first man in St. Ives to make ice-cream and take it in the streets for sale. Of a Saturday evening, after a hard week's work, he and young Jacob would go out with a canister full of ice-cream and return before nine o'clock with it empty.

For the first five seasons of his life in St. Ives he continued to do coastal fishing on boats called the *Two Sisters* and the *Faithful*.

But his main concern was with the business he was running for Denley. He bought up scrap iron, sails, rope, odds and ends of all kinds from the boats, and

made a regular tour of the town with a sack on his back, calling: "Rag-a-bone! Old iron!—Old iron! Rag-a-bone!" He became known in the town as "Old Iron," and is still remembered as such.

As things improved he bought himself a donkey and spring cart. The donkey was named Neddy. Wallis was a great lover of animals. He treated this one with gentleness and affection, never using a whip, and keeping it beautifully groomed and clean. A part of the cellar was partitioned off for its stable, and a door built so that the donkey could look out into the street. This caused some feeling among the neighbours. At night, hearing the fishermen returning home from their boats, it would "bleat loud."

"Darn 'e. I'll *kill* that donkey a' yours one day—yough!" a fisherman said to Wallis—"makun that hawful row nights, right up in the town!"

All Wallis said was: "I can't help it. Yud better stuff somp'n in's mouth!"

Wallis' sense of independence was always strong. It was one of the factors which, working in him, drove him gradually away from the community and made him a hermit, keeping, as he often told Ben Nicholson, "no company, male or female, town or country." But in the story I have just related there was an element of good humour.

Connected with this period there is a story of considerable significance. Alfred Wallis kept fowls in his back yard. His next-door neighbour, Mr. Lander, also kept fowls. Among Lander's birds there was a big rooster, who was always coming over the wall and fighting Alfred's rooster. This was annoying Wallis, but instead of saying anything about it he wrote to his old friend and step-son, George Ward, explaining the circumstances and asking for an English Fighting Cock to be sent. George was at that time farming in Okehampton. In course of time a huge fighting cock bred in the true English tradition arrived at Bethesda Hill. Alfred took it out to the back, put it in a hutch and waited. When Lander's rooster next appeared on the wall he let the cock out.

The delight of the event still lived in the voices of Mr. and Mrs. Ward as they told me the story. "This 'ere fightun cock wen straight for 'un, you. 'E was h'up h'on the wall in a moment, an' with the first thrust of's great spurs 'e *kill'd* un!"

There was trouble over this. Lander was angry. But all Wallis said was: "Well, I hope 'e'll be satisfied at *that!*"

The cock was sent back.

This was Alfred's spunk. A defiant, creative gesture in the face of the world, showing both imagination and strength. The whole thing stands out vividly as a marvellous symbol, reminding us a little of Moreland and his pig.

When the donkey died Alfred was very upset; it was most truly his own child who worked *with* and not *for* him.

39

It was the same with all his animals. He had a tame duck that used to waddle about the place. The children used to play with it and annoy it in various ways. The old man didn't take much notice: he left them to their games. But he was very attached to the bird.

Following the death of his donkey he set out on foot for Okehampton—a distance of about a hundred miles. While he was there he bought a Dartmoor pony for £14 and walked her home in two days. This enormous energy can be compared with the walks made by Van Gogh both in England and France. Wallis brought the pony to bit within a week. He used to take her down on the "Island" and run her around on the grass by the sea at the end of a long rope. No violence was used.

So instead of the old Cornish donkey he was now seen about in his spring cart with Fairyfoot, the little Dartmoor pony, with the shiny tail and smooth coat in which Alfred took such pride.

The business went very well. Ellen Bryant took over the whole of the clerical side, writing the letters, keeping the books and so on, because "Alfred was not very good with the pen." Susan worked in the cellar, packing the stuff her husband brought in on his cart, while he weighed it up on an enormous pair of scales. Once a fortnight Denley sent over a Mr. Gilbert with two waggons to collect what was ready. Each waggon was drawn by two horses and carried one ton. They came by way of the Nancledra road, over the moors, entering St. Ives from the south-west down the Stennack, past the fields where the council houses now stand. But the return journey was always made by the St. Erth road to avoid the hills. Wallis accompanied the waggons back, loading his own cart with anything that was over, but he himself refused to ride. Mr. Gilbert said: "I never once, in all the years I worked with 'en, know'd 'en to do anything but walk Penzance—'cos of'z donkay, yough!" Later, Fairyfoot made the journey, and it must have been on his returns, jogging on the shaft of his spring-cart over the moors at evening, that Alfred gathered the experience that produced his beautiful, mysterious, often macabre, landscapes later on. For just as he understood storms, fish, ships, the sea, he also understood beasts, birds, trees, massive hills.

A sweetness grows out of Wallis as well as a violence. He was, finally, such a complete person. The range of his emotional life was wide enough to include all the feelings we humans are subject to. One cannot help pausing with him on the moors as he rides to the short clatter of the pony's hoofs, because we know so well what he felt as he watched the birds hopping about in those short withered trees that he charged with such adequate life, or glanced up at the hills.

Wallis had the faculty of giving us his own first-hand experience in a marvellously convincing way. And, for him, that experience was often tinged

with the kind of mystery with which Poe and Coleridge made us familiar, but in no way intellectual in their sense. His was not an invention of the mind but an almost uncensored insight into the primaeval life that charges the crater, the rock and the broken hill. The animals are phantoms, ghosts haunting the centuries. It was the forms, colours and their relationships he *invented*, not the life he breathed through them.

With this in mind it seems incongruous to think of him as a hard working man of business, weighing his rags and chains to the last ounce to defeat—or at least be equal to—the degenerate Denley. But it was so. And it was this very fact that made life work out during those days. He had economic security, but, for all that, security built on a cliff-edge. When he stopped on his way across the moors, or stood watching the sea, his deeper consciousness of being came into action, playing through the particular mood of his personality at that time.

I have explained already of what nature I believe this consciousness to be, but it will be as well to reiterate here (accepting its existence) the fact that it is the most primal quality in our human make-up and is charged with the same fundamental power as the creations outside us: is in fact a further manifestation of the same thing—at this level I believe there is no division: the content of subjective and objective are identical. Wallis touched this universal quality, and that is why, as H. S. Ede says, he was "never local."

Business activities solved the conflict of several issues in his mind and helped him largely to this deeper consciousness by making him still, and bringing about a state of harmony and equilibrium. In his landscapes, which grow largely from this period, we do not meet with the violence of the earlier sea paintings. It is evident that he drew his experience of landscapes from other places than Cornwall, possibly from Leghorn, Genoa, and other Continental ports—also from Canada and even South America. The extraordinarily un-English, chateau-like buildings in some pictures, and the wealth of plant life and animals and birds are quite distinct from the Cornish landscapes as such.

The remarkable thing is that in both the landscapes and the sea paintings, the imagination is always equal to the expression of the experience.

In 1862 William Booth conducted a mission in St. Ives. From that date the Salvation Army took root in the town and grew in strength. A loft on Market Strand, next door to the house in which Wallis had first lived when he came from Penzance, was their headquarters, and from there they went out to preach the gospel, marching round the harbour with their band and holding services in the open air. It was not until years later, in 1936 or 1937, that a new and substantial building was erected for them on the same site, next door to the present Lifeboat House, quite near the church. One of the moving things about life in St. Ives is to walk on the wharf of a summer's evening and come

upon a circle of these curiously serious people holding a service. Fishermen, loungers, soldiers, children—all will be standing round. The Captain will announce a hymn; he will recite the first verse loudly, then, taking their cue, the band will start up and everyone bursts out singing. The well made by the harbour, the coloured houses, the hills, the sea, are filled with the praises of these people. The fishing boats lie impersonally on their sides on the sand, the seagulls continue their beautiful performance.

An immense amount of energy is used up, working from soliloquy to dramatic expostulation, and from thence to ecstatic joy, fortified by cornet and concertina.

The whole concept of the Salvation Army is so delightfully theatrical and strikes a familiar chord with our experience of the music hall.

Susan had already become a Salvationist before moving from Penzance, but it was not until March, 1904, that Alfred was "saved" by them and enlisted as a soldier of Jesus Christ—more than likely through the influence Susan brought to bear on him, though he was obviously open to it. He did not deny the Salvationists at any stage of his life from that time on, but nevertheless was not an enthusiastic attendant at services as far as I can gather. In his old age he emphasised time and again the fact that he was always struggling to keep his own personal belief in the Bible, and to interpret it as *he* believed right. When arrangements for Wallis' funeral were being made with the Salvation Army Major Holley told Adrian Stokes that Alfred's name had been crossed off the roll.

Susan, on the other hand, was such an energetic worker for the Salvationist cause among her fellow men, that for many years after her death she was remembered for her cottage meetings.

It is in connection with these meetings that I have traced the first link with a portable organ, or "melodian," which Alfred used to play to himself as an old man after Susan's death. It was originally used for these meetings conducted by Susan in the cottages of the fishermen, but whether it was Alfred who actually played on those occasions I have been unable to find out.

It was a curious instrument. The performer sat on a chair with the organ on his knees, operating the bellows with his left hand at the back and playing with his right. We will come to it again.

Susan's favourite text was "Whosoever believeth in ME shall surely be saved." "I am one of the 'whosoevers' " she used to say. Her most cherished hymn was 'T'Would Ring The Bells of Heaven.'

Between these meetings and the hard days working in the cellar it is almost startling to add that Susan was also a Sunday School teacher.

About Alfred's private life during these years I can only get two statements—that he was very quiet and kept to himself, and that "Mrs. Wallis wore the trousers."

It would be wrong to deduce from this that Alfred was unhappy—or, conversely, that he was happy. But the circumstances of the little of his history we know up to this time do help us to see under what discipline he was living. He had his religion and his work counter-balancing one another, enabling him to carry the weight of responsibility growing from a large family (for even though some of the children had grown up and married he still helped them in various ways), and to control the pressure of the things within him which, as we have already seen, had not yet found a way of fulfilment.

Susan was, in point of fact, the victorious Mother. She not only dominated Alfred, but also held the purse-strings, always with an eye to the well-being of her children. And it must be remembered that Alfred, besides being her husband (hungering for love), was in truth only her adopted son.

It is not to be supposed that this was an unhappy marriage, as would appear from outside, for all reports say they got on well together. It *is* a fact that Cornish people, having evolved their family system as a protection against want, look upon marriage as fundamentally a business arrangement, and because of this, if for no other reason, man and wife usually stay together until death do them part—their emotional bond being preserved in the children.

The discipline asserted over Alfred's life made him a quiet and curious man, a man of great energy and integrity, giving no immediate hint that his voluble and sociable wife was his wardress, enforcing an agonizing and sterile chastity over him—save in the startling impulse that resulted in the incident of the English Fighting Cock.

6

Victoria was dead—Edward on the throne. In the world surrounding Wallis evidence of disintegration, under the advancing tide of Capitalist-Democracy and the machine, was becoming rapidly apparent. While the Edwardian sunlight fell peacefully on the unsuspecting ladies and gentlemen in their summer gardens, the deeper patterns of the age were beginning to shift. Alfred's world was still under Victoria, having been left by the receding tide, yet the power that had now started its gradual invasion was itself breeding the complex circumstances that were to find their setting for 1914.

It was in this ebb and flow that Wallis' life was dismantled.

The fishermen who had worked as a community for so many years, on a share basis, were faced with the growth of large fishing industries in other parts of the country—at Grimsby, Yarmouth, Lowestoft. The firms that sprang up built large steam trawlers, which, voyaging round the coast, not only cleared the seas of fish but also caught all the spawn, forestalling the seasons to follow. The St. Ives fleet, with only their sailing craft, were not able to compete. And when it did happen that they had a good catch, the markets, being controlled by these larger firms, offered no price worth taking and the fish had to be thrown back in the sea.

Sometimes the fleet would be away on coastal fishing for weeks, going as far north as Scotland, and would return with nothing to show for their efforts, while the wives at home had been living as best they could on credit given them by the little grocers' shops which were part of their community. There was no dole for them until quite recent years. The fishermen waged a hard fight for a government grant to enable them to buy engines, but it was not until the beginning of the 1914 war, when the larger trawlers were out of commission and fish was needed, that they obtained it.

Meanwhile, under this gradual economic pressure, the industry was breaking up. Men who had worked all their lives at their native trade no longer brought their sons up to follow in their ways. By 1907 they were selling up their boats—boats built locally with Cornish hands and prized and loved over years of seafaring—often letting them go for as little as £1 each. Some even sailed their craft to Ireland to find a buyer.

Having forsaken their nets they went down into the tin mines to earn their bread and keep their families. Others emigrated to America and got jobs in the huge automobile factories of Henry Ford. Almost at one stroke the advance of civilization (the *machine* age one would prefer to call it) exterminated an ancient and primitive community, which, had it been given instead the

advantages of cultural and economic development, would have proved England to hold the deeper issues of reality that go to make a truly great race.

Wallis was not of this age. By contrast he was of an age in which, at least among the peasantry, and to some extent on other planes of society, awareness of the vitality of the race was a living factor: the vitality that had given us Chaucer, Hogarth, Blake and the cromlechs of Zennor.

Alfred Wallis was alive to the sap in his veins. He knew the rock was not barren, nor the hill childless. The roughness of the heather root was the texture of his being, the force and violence of the sea broke continually against the walls of his heart. Though he spurned the society of men, they grew from his fingers. The lie of civilized life as we have come to know it never gained precedence over these things in Wallis: it smashed the discipline already imposed upon him and his innermost being flowed through, creating, under terrible circumstances, the poet of a primitive and oppressed people.

As the tide of industrial progress washed over St. Ives, Wallis' business began to go down, for he depended on the boats and on the town for the merchandise he bought for Denley. The seineing boats on Porthminster Beach had disappeared for ever; only a few luggers remained in the harbour. In 1911 we find him able to afford the two large cars which he hired to take all the St. Ives branch of the family to Penzance for his brother's funeral. But in 1912, while the savings were still intact (or so he thought), he closed down the business. The step-children were out in the world. Alfred was left alone with Susan, who was now 78: he being 56 years of age. Together they moved to No. 3, Back Road West and took up residence in the little two-roomed cottage which, to those who knew and helped Wallis in his last years, has become so familiar.

Of the ten years following this change, which mark the next period of Wallis' life, I have not been able to find much that has any direct bearing on the making of his personality.

The retired couple had bought the cottage; this far they had realised their ambition, by saving enough money over years of work to stabilize and protect them in old age. Their expenditure was small. They rested on the small capital it is known they had at this time, but it is unlikely they touched it for anything that was not essential, for there were not only the years ahead—fewer for Susan than Alfred—but also, at the end of that time, there was the expense of a coffin and grave for each of them—an important factor they would both have given every consideration.

We can construct a rough idea of how they lived at Back Road West.

Susan was in receipt of her pension, which was supplemented by the money Alfred earned doing odd jobs. He worked for Mr. Armour (Senior), who at that time owned the antique shop in Fore Street; moving furniture about

45

among the most extraordinary and varied collection of objects and images ever brought together by the hand of man—almost as strange as the Surrealist's "fortuitous meeting of an umbrella and a sewing machine on a dissection table." In Mr. Armour's shop there are Regency samplers, African shields, ships' compasses, Dresden china, kitchen chairs and billiard balls—pattern locked in pattern, memory in memory.

It is interesting that Alfred was once more drawn to a world of *images*, of discarded *things*, of objects made by men and not God, just as he had been in his rag business. Apart from the financial motive that drove him to such a place, I am quite convinced that something else in his nature needed such objects. It is almost as though he were turning to the tomb of history for confidence in life—the departed, the disused, the broken—images, rags, bones, death. Had it been a sampler made by mouldering hands, or a painting of a ship he once sailed on, it told the same story, and within him struck a sympathetic note with the chord of destruction that had already sounded—both in religion and life—the death of the self. Out of this grows the sweet nostalgia of a Chinese poem.

Among such things he must have satisfied his strong sense of form. The immaculate form of a pig's scapula handled in his cellar would no doubt have given quite a profound pleasure to Wallis. The varied inventions of the mind collected by Mr. Armour must have enriched his imagination, for (quite apart from their aesthetic qualities, which were not absent in some cases) here was another world of creation—the Third World of Man—an extension of life.

In the curious colour of some of Wallis' paintings, the dull reds, browns, greens, golds, blacks and whites, one is reminded of the collective archaic colour-experience a visit to Mr. Armour's shop will produce. It cannot be said that here is the origin of Wallis' genius for colour—that would be absurd, for an artist's colour is the product of his entire personality, his *Linga Shirara*—from birth to death—but certainly this place must have had a fairly strong effect upon him, though I don't suppose he was aware of it.

During the Great War he worked on the "Island," building Government huts.

In 1915 he was summoned to appear at the Town Hall for arrears in poor rates amounting to the sum of 5s. 6d.

Susan, it seems, carried on her work as a housewife and attended to her religious duties. Her remaining children kept in touch with her, and were, most likely, no exceptions to the custom of helping their mother with the washing and odd household jobs.

George Ward had died in 1896, twelve years after a serious accident on a threshing machine, in which he lost his right arm and right leg. The tragic fate followed his wife, who was burnt to death by a candle in her coal cellar at Launceston some years later.

Emily had married, but was now in her grave. Only Jessie—who had married a fisherman, Thomas James Williams—Jacob, now husband by second marriage to Ellen Bryant's daughter, and Albert, were alive. Jacob was a postman and Albert a baker.

Susan had buried sixteen children.

The interior of their cottage was plain and simple. A rectangular and a circular table, a couch, chairs and a Cornish range, in the tiny downstairs room, on to which the front door opened. At the window was a lace curtain. Large portrait photographs of Wallis' father, of Alfred himself and of Susan, hung on the walls. On the mantelpiece was a stuffed magpie in a glass case. At the back of this room, behind a wooden partition, was a small space used as a scullery. Here also they had an indoor earth lavatory, which was emptied at intervals on the Porthmeor Beach at the back of the cottage. From the scullery Susan and Alfred climbed a small wooden staircase to their bedroom, by the light of oil lamp or candle.

They lived quietly enough, watching the years, exchanging the news of the town and sharing the companionship which years of hardship bring to men and women. Susan still sometimes worked at her bobbins by the fire, just as she had done forty years before when Jacob was a little boy. Her fingers remained nimble. She and Alfred read together from the big Family Bible in which the births, deaths and marriages of all the family were recorded. Alfred's dreams were beginning to take shape, but he mixed very little with his fellow men, and had little or nothing to say, save when he talked of the sea or the Bible.

As time went on Susan's strength began to fail. She took to her bed and was attended by Dr. F. C. Matthews. On June 7, 1922, she died. She was eighty-eight years of age. On June 27 Alfred paid a bill to the amount of £8 15s.—for "making a Pitchpine Coffin."

His last companion had gone.

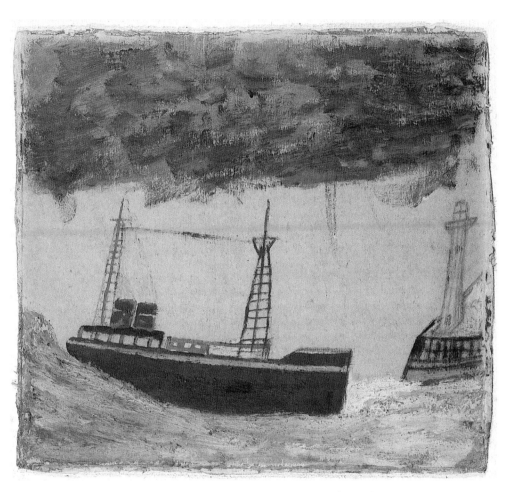

1 *Steamship in harbour*. Oil on card $9\frac{3}{4}''\times10\frac{3}{4}''$.

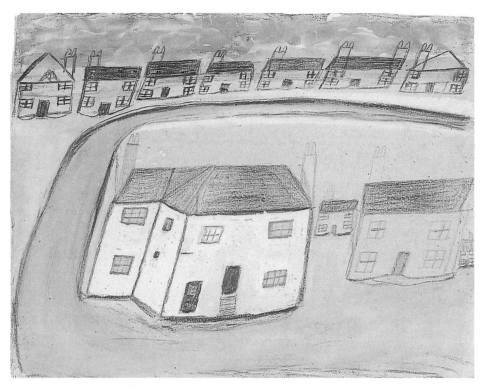

II & III *White house and cottages* and *Small boat in rough sea.*

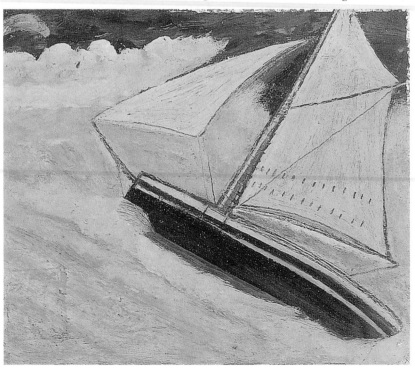

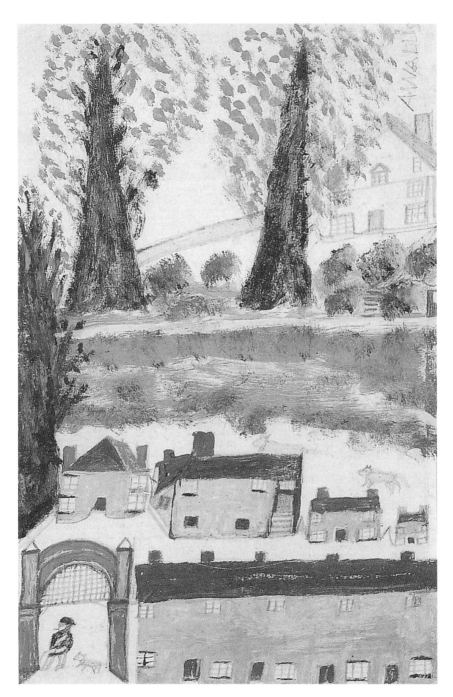

IV *Gateway*. Oil and pencil on thin white card.

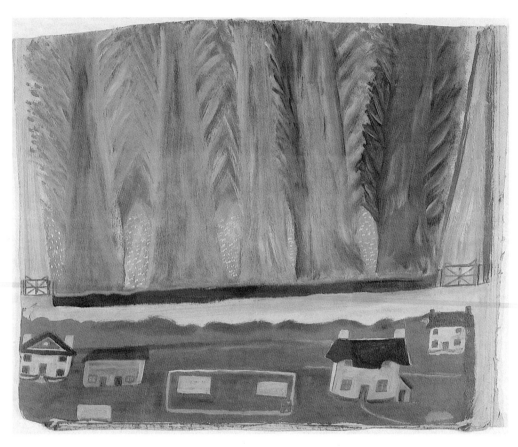

V *Cottages and trees*. Oil on card $18\frac{3}{4}'' \times 22\frac{1}{2}''$.

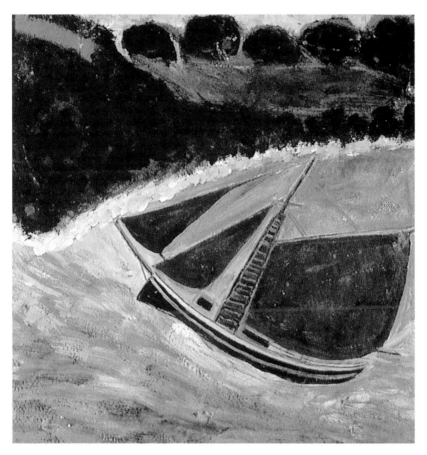

VI *Fishing boat off the coast.*

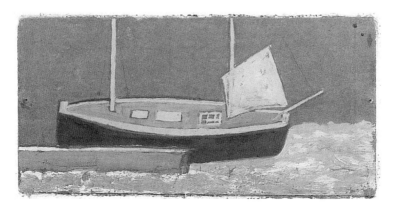

VII *Trawler by quayside.* Gouache $3\frac{1}{2}''\times8''$.

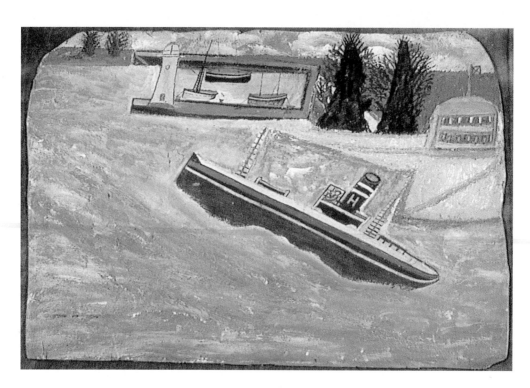

VIII *Trawler passing a lighthouse.*

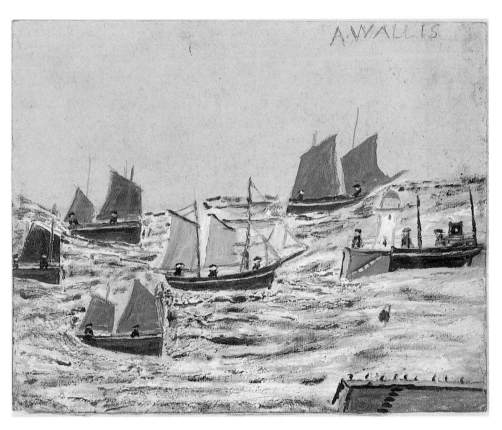

IX *Sailing boats entering harbour*. Mixed media $9'' \times 11\frac{1}{2}''$.

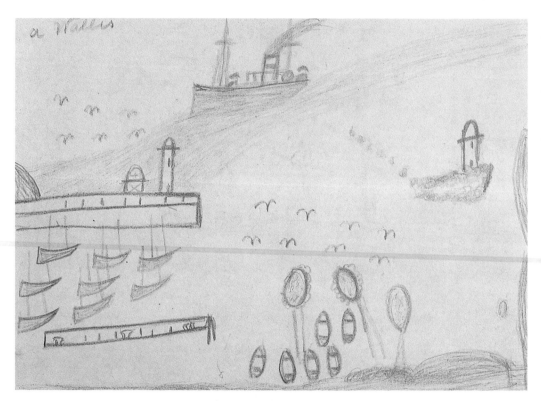

X *Lighthouses and ships, St. Ives*. Crayons $10\frac{1}{4}'' \times 14\frac{1}{2}''$.

7

It is not perhaps possible for younger people to know the feelings of an old man sitting by the fireside during the first weeks after his wife's death. The yawning loneliness, the heartache, the dismay; the tricks played by years of habit, and the pent-up unexpressed feeling: all this swings us toward a world of experience many of us will never touch at first hand.

What was Wallis' feeling at this time? We cannot tell. The book is closed. In that isolation he must keep his suffering to himself for ever, lit dimly by the light I have endeavoured to cast on him. We have a slight knowledge of his past life distilled before us. There are the paintings, with all their cargoes of human experience, and above all the beautiful archaic *Portrait of a Woman*, but we have no voice, no utterance that we know of. The silence of his cottage and the adamant green front door will not give up their secrets.

I am at a loss how to continue. There seems only one way open. At least it makes a link between the two sections of his life.

For the authenticity of the event I am going to tell I rest on my usual sources of information—that is, the statements of Wallis' friends and relatives. I have no proof of its truth or accuracy, but one may safely judge that something of the kind did occur, for Wallis himself is reported to have given many an account of the story.

It is simply this:

In the bedroom of their cottage Susan and Alfred kept an old trunk in which clean and best bed linen was stored. Along with this linen was the sum of £40 in gold and £5 in silver. During Susan's last illness the children then living were constant visitors. Their mother was growing weaker each day, and "a bit light in the 'ead." After her death Alfred went to the trunk to find out his financial position, only to discover that the money was gone and all the bed linen and blankets changed for old ones. It is generally thought that Albert Ward was the culprit. Each week when he took the laundry home he had exchanged the bed-clothes, and on returning them to the trunk had helped himself to the money until it was gone. Albert died in 1928, aged 65.

According to another report Alfred did not say *who* took the money; he simply said: "All I know, it wasn't there afterwards!"

It was after Susan's death that Alfred turned on the Wards, saying he wished he had never met the family. Apparently he was under the illusion that there was quite a lot of money saved against his old age, but it turned out that Susan had been continually helping her children through difficulties, and although it is said that in earlier years Alfred had always shown himself willing to be of

49

assistance to them, he nursed a strong grudge about it later, just as he had done with his brother Charles; this grew as time went on. He refused point blank to have anything to do with them. Even as late as 1942—twenty years after Susan's death—if Wallis was sitting in Mr. Curnow's little barber's shop in Gabriel Street waiting for a shave and Jacob Ward chanced in, "Mr. Wallis would take no more notice om then if 'e want the-ur!"

Jessie and her husband, T. J. Williams, offered to help Alfred in various ways, such as taking in the washing, but he would not allow it. Mr. Williams was obviously fond of Alfred, but said: "He was what we der call *piggy-'eaded*," and with no unkindness whatsoever, but with a tremendous force for a very old man, added: "Alfred Wallis got what he looked for: he looked to be without a friend—he died a hermit!"

Jacob and his wife met with the same treatment. At Christmas time they were in the habit of sending him down a Christmas dinner, ready cooked. One year Mrs. Ward, after delivering the dinner, called in on Mrs. Peters next door, for a chat. During the conversation Mrs. Peters said:

"Tes good of 'e, dear, but I don't know why 'e der trouble to send 'en that there dinner. 'E ony thron it away!"

Mrs. Ward was rather dismayed.

"Well you wait 'ere a bit and see," said Mrs. Peters.

They both watched through the window. After a little while the short figure of Alfred came into view, dressed in a seaman's jersey and very baggy trousers. In his hand he held the plate of dinner, which he scraped into the gutter.

"I'm not going to take no Christmas dinner from no Wards," he said out loud, and went back in his cottage, slamming the door.

"The-ur, me dear," said Mrs. Peters to Mrs. Ward, "'e der think you be try'n to paison ob'n!"

This idea of people trying to poison him was quite frequent with Wallis. Andrew Armour—son of Mr. Armour who kept the antique shop in the earlier days—has a similar story. It is the beginning of what has been called "Wallis' persecution mania."

Of the relations it seems he kept on speaking terms only with William Wallis, the son of his brother Charles, and was induced to take up residence in his nephew's house. But the arrangement did not last very long. One evening Mrs. William Wallis went to the room they had given Alfred, only to find him gone, "lock, stock and barrel." He had returned to his cottage, from whence he refused to budge.

In making any comment on the help Wallis deserved and should most certainly have had, we must bear in mind how extremely difficult he became, and this did not grow less as time went on.

Fortunately there had been a little money in the Post Office on which he was

able to live for a short time after Susan's death. When this was exhausted he mortgaged his cottage to a Mr. Spinks for £50. This was arranged by Mr. Armour (Senior), who was one of those who saw Wallis' first paintings and encouraged him to go on. Mr. Spinks later sold the cottage to Mr. Care of St. Ives, on condition that Care did not take over until after Wallis was dead. This money carried Wallis over another patch of time. He supplemented it by selling odd articles of furniture in the house. In 1925 he was seventy and became eligible for the Old Age Pension. I don't think he drew Public Assistance to help him through this difficult time, but it is certain he starved a good deal.

He had one friend at this time named Mark Hollow. Hollow was a very religious man. He used to visit Alfred frequently. They spent their time reading the Bible, talking and singing hymns to the old "melodion," which Alfred played. But Hollow died.

It was about this time that Wallis' mind began to show the first signs of breaking down, and developed what he called his "wireless brain." Wireless was becoming popular: to a man so retarded and against civilization and its inventions it could well have seemed an unholy thing. It was indeed a manifestation of the Invader, and he thought, logically enough, Satan was working his destruction by this means.

Simultaneously with the appearance of wireless he had begun to hear voices when he was alone in his cottage—especially at night: they called him "a damn Catholic," "a Methodist," "a thief," an "Irishman," each representing a different religious body, trying to drag him away from his own belief in the Bible. The room upstairs, which he had not entered since Susan's death—save to hang up his washing—was taken over by the Devil: it was from here the messages were sent down at night. They also came down the chimney.

Every two or three months Alfred went round to the antique shop to ask Mr. Armour to come and help him.

"For God's sake," he would say, "come round an' gimme a hand to clear away they wires!"

Mr. Armour entered the fantasy without comment, and went to the cottage with a ladder, an old clock weight, a handful of straw and a length of cord. He climbed on to the roof, tied the weight and the straw to one end of the cord and let it down through the chimney to the hearth of the living-room—"Kitchen" it was called. This repeated two or three times put the old man's mind at rest, and several weeks would go by without disturbance.

As the years went on this complaint grew worse: anyone he disliked (and he suspected most people) he might easily pick on as a "sender of messages." One day he was standing outside the antique shop talking to Armour when Mr. White, a local carrier, went past with a load of chair and bed-springs. Wallis became silent.

51

"There 'e goes!" he said after a while. " 'E's one of en!" The springs were part of the wireless equipment.

The obsession developed in a most interesting way, as we shall see later.

Besides Mr. Baughan, the grocer, Mr. Armour and Mrs. Peters, there was another man who befriended Wallis during the last twenty years of his life: Mr. Edwards, a watchmaker, who kept a shop next door to Mr. Armour's shop in Fore Street. It was Wallis' habit to go there every afternoon and chat, and, as an old sailor said—slyly, for Wallis was stone deaf in later days: "to listen to the clocks!"

The interior of Mr. Edwards' shop was a new world—the world of clocks. Clocks everywhere, of every period and fashion, all ticking at once, along with hundreds of watches, strung from the shelves. Behind the counter, almost hidden from view by the timepieces piled on the show-case, sitting at a low bench in the window, was the watchmaker, amid a wilderness of springs and tools. He worked with such silent absorption that one might almost have believed he was taking the universe to pieces to discover the principle of its mechanism.

When I first entered the shop he took no notice. Finally he turned round to see who it was. I mentioned Alfred Wallis but he showed no response. Then after a little while something began to flicker in his face like the fine hair-spring of a watch. He got up, wiping his hands on his apron. He was tall and stooped, with sensitive fingers. His face, for all its age, was young. I had the feeling that he knew the secret about time and it made me feel happy.

"Yes. I knew Alfred Wallis," he said. "He used to come in here for a bit 'a chat."

Edwards talked mostly about the painting. He told me how Wallis had come into the shop one day about seventeen years before and said:

"Aw! I dono how to pass away time. I think I'll do a bit 'a *paintin'*—think I'll *draw* a bit."

"When he had said this," Mr. Edwards continued, "Alfred went next door to a little old shop that sold paint brushes, wallpapers and such like." Picking up a water-colour brush from among his tools, "like this," he said, stroking the paint brush with his thumb. "He bought two. From there he went to the paint shop in the Digey, Mr. Burrell, and bought some ordinary house paint."

While Mr. Edwards was telling me this his eyes began to sparkle with delight. His voice was thin and he lisped a little.

"Well, next day, the old man—he was only a little slip of a man you know—he came in here with two or three paintens of *boats* an' the like; an' they were the very fust paintens 'e did, you.

" 'What do 'e think on they?' said Mr. Wallis—proud as y'like.

" 'Come,' said I, 'let's put 'en up an' look on 'en a bit!' an' Alfred stood 'en

52

up on that ole clock there." Edwards pointed to an old black wooden clock hanging behind the door, "the very same one!"

"Um by," continued the watchmaker, "h'in come Mr. Armour—that's the fayther to the present man.

"'Who painted the pictures?' he asks.

"'I did!' says Mr. Wallis" (here the watchmaker managed to convey something of both pride and modesty—very serious).

"'An' how long you *bin* painten then?' says Mr. Armour.

"'Aw, I jus' started ony this week—but I *gon do some more!*'

"Mr. Armour considered the paintens again.

"'Waal. H'all I can say, me lad, is, you done a mighty fine job by en!'

"So from then on," concluded Edwards, "he wen on painten," adding as an afterthought: "Mind *you*, Mister, *he could paint the say!*"

While I was in the shop customers came and went, the bell ringing each time the door was opened: between each one Edwards searched in the back of the shop among the clocks for some of Wallis' paintings, finally producing seven, done on old pieces of cardboard and wood, which he gave to me as a present before I left.

I was looking at these, their lovely colours glowing through the dust, when a fat thick-lipped man came in for his watch. While Mr. Edwards was looking for the watch the newcomer stood staring at my hand turning the paintings. "Some of Alfred Wallis' paintens," said the watchmaker, with his back turned.

It was a long time before the fat man showed that he had heard, then distantly, as if to himself—lifting his chin off his ready-made tie—he said: "Old Iron!—Old Iron!"

"That's right," said Edwards, thinking back: "Old Iron!"

The creation of Wallis' paintings and his curious personality had been an event in the lives of these people.

What first put the idea of drawing and painting into Wallis' mind is not known for certain; but there is little doubt that the obvious answer is the correct one. He lived a few doors away from the Porthmeor Art Gallery; artists surrounded him on all sides: they could be seen at work on the harbour and in the streets, with their easels and canvases before them. Perhaps, on that summer day, he had stopped and watched one of them at work—painting, even, one of his beloved boats—on his way round to Mr. Edwards' shop.

For a man so lonely and bored, with a past like his and a creative urge pent up in him for so long, it seems only logical that some such incident as this, slight as it may seem, would be enough to split the pod of an idea that had been germinating for years. And the fact that he was always referring to the St. Ives artists as "real painters" suggests that he had a clear distinction between himself and them from the beginning. He himself was "*not* a real painter."

53

Whatever the truth about this may be, we can safely say that some minor happening was sufficient to unlatch the deeper motivations to paint, which I have already endeavoured to make clear.

The theory that Wallis first started to paint by accident, with some paint left over from decorating the interior of his cottage; that the ships on the green wooden screen just inside the front door, and the boats painted on the plaster by the lower front window are the result, is disproved by Mr. Edwards' story.

But certainly Wallis painted with ordinary ship's paint, or house paint, to which he was obstinately faithful until he died.

With the help of careful calculations made by Mr. Andrew Armour and Mr. Edwards, also, independently, by Mr. Baughan, I fix the date of Alfred's first painting as the August or September of 1925, three years before Christopher Wood and Ben Nicholson made their discovery, and I think it very doubtful whether the paintings these two artists found were "among the first ones he did," as Nicholson claims in his article on Wallis. But I must confess that I cannot press my point here, since the exigencies of war have prevented me from collecting the facts that would prove my opinion.

It is interesting to notice that Wallis did not see painting apart from drawing, as so many beginners do. "I think I'll do a bit'a painten—think I'll *draw* a bit!" he said.

8

The story Ben Nicholson tells of the day he and Wood first discovered Wallis is rather delightful. At that time the Nicholsons were staying over in the direction of Falmouth: it was August, 1928. Kit Wood had been previously to St. Ives, and the paintings he had made there, along with his enthusiastic descriptions, filled Nicholson with the desire to go and see for himself. The arrangement was made, and one hot day they set out together in an old-fashioned Ford, T-Model, which was driven by a man sitting bolt upright on the high seat behind the wheel, with a bowler hat stuck on top of his head. They pulled up at the coastguard's house near the Malakoff, when Nicholson looked down on St. Ives for the first time. The car was dismissed and told to come back at the end of the day. Wood and Nicholson, each with their drawing things, parted company, arranging to meet on Porthmeor Beach in the afternoon. It was after they had met again, and were wandering along Back Road West, that they noticed, through the open door of No. 3, naïve paintings of houses and ships nailed to the wall.

"Look at those!" said Nicholson. "We must go in." And with Kit at his heels he entered the cottage, to find Wallis working at the table, looking, as Stokes and others have said since, "just like Cézanne."

In those days he was not deaf and quite sensible. One can imagine the suspicious reserve these two young artists awoke in the old man, but he did not turn them out. Their enthusiasm over his paintings must have pleased and surprised him. When he was asked if he would sell some of them, and how much he wanted, he confessed he had never thought about it: he painted simply "for company" as he was lonely after his wife's death.

"Aw," he said, "gimme what you like!"

He made his first sale on that day: the paintings Nicholson and Wood took away with them were the first to go out and have their effects upon the world, for not only did they influence both these younger artists, but were enthusiastically shown among their circle of intellectuals, collectors, painters and friends as the work of a newly-discovered and genuine "primitive."

The following statement written by Christopher Wood is a frank and grateful salutation to one artist by another.

"I am more and more influenced by Alfred Wallis—not a bad master though—he and Picasso both mix their colours on box lids! I see him each day for a second, he is bright and cheery. I am not surprised that no one likes Wallis' painting. No one liked Van Gogh's for a time, did they?"

The effect of Wallis on Wood as shown also in his paintings corresponds

with this. The meeting came at an important time for Wood and gave his vision such a twist as to lead him back through the complex sophistication of his cultural development to some unique naïve quality of innocence within himself that had remained intact.

It is of interest that Wood, who was a vital personality, found the old man "bright and cheery."

The influence of Wallis on Nicholson was of a different, almost opposite, nature. It is most markedly seen in the Cornish landscapes. Instead of leading back through Wallis to his own "innocent eye," he gathered that which has most moved him in Wallis' work and drawn it up into his own stratosphere of sophistication, with the effect of having sterilized the images of hills, animals, boats in the Lysol of his own thought. Although Nicholson assured me that there were "much stranger animals in much stranger landscapes of his long before he ever met Wallis," I am not alone in my conviction that the parallels in the work of these two men are not merely incidental or fortuitous.

After their day-visit Nicholson and Wood moved to St. Ives for three weeks. Wood stayed on for about two months in "Meadow Cottage," behind Mr. Baughan's shop. He is remembered by Mr. Baughan as "an excitable and nervous young man." The cottage was close to No. 3, Back Road West, and it was then that he saw Wallis "for a second each day." It was in March, 1930, Wood visited St. Ives for the last time—he met his death soon afterwards: under a train at Salisbury Station.

Nicholson visited Wallis again in 1933 and 1939, after that periodically until Wallis' death, and otherwise kept in touch with him by letter, over a period of fourteen years, though there were long lapses of time when there was no communication between them. He tells me he usually had a painting by Wallis on the mantelpiece in his studio in London.

Wallis was pleased and encouraged by the interest shown in his work by this growing circle of admirers, which was soon to include H. S. Ede, Herbert Read, Adrian Stokes, Barbara Hepworth and others. Ede, at that time assistant at the Tate Gallery, never met Wallis, though he corresponded with him and was a great champion of his work.

When a cheque arrived in payment for paintings Wallis would take it round to Mr. Baughan or Mr. Armour and get it cashed, showing the accompanying letter with great pride. I print here a letter from Ben Nicholson:

<div style="text-align: right;">

20 Dulwich Common,
S.E.21.
Feb. 18, 1929 (?).
</div>

"Dear Mr. Wallis,
 Many thanks for the new paintings. There are some lovely ones among them, and we like them very much. Mr. Wood and Mrs. Nicholson both liked one of

them as much as any you have done—one with the land like clouds behind a ship with white sails, blue sky, yellow sun.

I am sending back 4 and have kept 9 as follows—

one	3/–
two	2/–
six	1/–
	13/–
Post	1/6
	14/6

and enclose cheque for 14/6 & hope this is correct?"

When Wallis had not heard from any of his admirers for a long time he got very annoyed, and would write to Nicholson of his own accord, sending along a parcel of paintings. He didn't like it either when paintings were returned. He was generous with his work; if someone cared for a painting he would give it to them (that, of course, is as it should be), and it was often quite difficult to get him to sell anything. It hurt him if one of his patrons called and left without taking anything. Consequently collectors worked out a scale of charges, going to 8s. for the largest ones.

The appreciation of these people is proved by the collections they made of his work, and the things they have written about it. As an example I give here an extract from some notes on Wallis H. S. Ede very kindly sent me from America, where he "gave a lecture on him to some highbrows and has never been spoken to again by any of them—they thought it an insult!!!"

". . . a great ship, anchored in harbour with that strange over-life-size feeling common to ships standing in quiet water. It has a sort of delicate assertiveness in which it is almost impossible to sense its cutting activity once it is on the high seas, even the lighthouse has come to rest, perpendicular instead of thrown at an angle, and the sails are furled like snow and emphasising the closing in of life . . ."

Ede was particularly inspired by Wallis' work and although, he tells me, he never set himself up as knowing anything about him, he loved everything he did.

I quote again to give an idea of how Wallis was seen by another of his contemporaries and appreciators.

Starting with an extract from one of Wallis' letters, the passage runs:

" 'I paint things what used to be and there is only one or two what has them and I does no harm to anyone'—so he leads his life, puffing his pipe, reading his Bible, and improvising strange melodies on a kind of organ he has and painting memories of the past on the backs and sides of cardboard boxes which he gets from a neighbouring grocer."

In the more mature light of the background of Wallis' life, the increasing filth and poverty in which he lived, this passage, beautiful and half-true as it is, strikes an incongruity.

Wallis was most certainly a magician, but the glory of his achievement must be seen squarely, without any trappings, against the tragedy of his life and his social defeat, for the fullness of that achievement to be properly appreciated.

The words of Mr. Baughan, with which I started this book, come back: "Mr. Wallis was always held aloof from those who were interested in his work by what *they* called his "queerness."

Now we know more about Wallis, and to some extent understand his queerness, we see two things: one, that his admirers saw his work before they saw its creator, and, two, that their picture of its creator, though in most cases they knew him personally, was a myth—which, if nothing else, would keep them safe from embarrassment, as the story of Van Gogh's ear has kept the whole world safe from embarrassment for fifty years.

I think this has in some degree prevented them from understanding the deeper content of the paintings as completely well as they undoubtedly have the aesthetic qualities of artistic *form*, for in the end Wallis made these one.

This is the general impression I have been given by most of the members of the circle interested in Wallis' art I have met.

The problem here is as largely social as artistic, and I emphasise the one to give balance to the other. Which is the more important, the art or the man? The art because of its transcendental qualities, or the man because of his humanity? The answer is *neither*—both are important, but the man is usually sacrificed.

There is an inherent inability of members on one level of society to understand the realities of the lives of those on another and lower level, and an inability of those on the lower level to give anything but a superficial impression of themselves to those over and above and outside their life, or to understand them. But until this is done, until life in all its aspects is seen as a reality by juxtaposed evolving individuals, little can be done to alter it—an effort towards selfless self-extensions.

The most consistent criticism I myself get for my own attitude to Wallis is that had he had a better time of it his work would never have come into being. That, in fact, I am driven to lament the very conditions which have produced the work that has inspired me to write about him. And I find it very difficult to answer, for it is largely true.

Ben Nicholson wrote to me:

"Of course there is always the possibility—a very real possibility—that one might have given Wallis all kinds of security and removed his urge to work. A friend of mine, who lives in the Scilly Isles, says how soft the Islanders have

58

become through leading soft lives. All the same we must have at *least* Beveridge!"

Had Wallis' life been different from the beginning, had it not, even apart from the economic problem, been so extraordinarily involved with tragedy and disappointment, had it, in fact, been normal, it is most certain that he would never have painted, or been, in himself, the dramatic personality he was. Right education, cultural, economic and religious environment seldom comes to a man born in Wallis' station of life. Had those things been his he would have been a happy integrated human being, which is the greatest creation a society can produce, and his natural creative capacities would have flowed into all the avenues and alleyways of daily life—who knows, may have overflowed into an art of *joy*, rather than one of pain and suffering. This way of life, not only for Alfred Wallis, but for all men on this earth, is something we dream of, fight and work for, but is far away from us at present.

Returning to the reality of the situation, it would have been unkind to have spoiled Wallis and his work with luxury and fame, which, being what he was, he could never have accepted in his own heart; and I don't believe he ever wanted these things. But the introduction of a certain security which would have assured him of normal needs, would only have served as a stimulus to his "urge to work," and in no way have destroyed his art. The man was humble, anyway he was tortured, and his love of the sea, of life and of God was far deeper and more enduring than the conditions that surrounded him.

What is said of the Scilly Islanders is no doubt very true (and the parallel is particularly suitable because Jane Ellis, Wallis' mother, came from the Scillies). Suffering cannot be avoided. The story of all history tells us how this companion of man has walked at his side down the centuries, since that far off day when he was first cast out of his "dim Eden"—and

> The dangers and the punishments grew greater
> The way back by angels was defended
> Against the poet and the legislator.

It is the way man engages with suffering that brings either depth and tenacity of spirit, or flabbiness, which is always the condition of decay. But excess of suffering is both stupid and destructive.

Though it may be said that all great achievements have grown out of hardship and sacrifice, we have still the lesson of those ages both in East and West when biological needs were satisfied, times when great cultures emerged, towering over the years, breathing the peace of spiritual contemplation and understanding, and it is on these achievements the greatness of the human races is judged.

The path of the quester is, it seems, must be to some extent, one of anguish, because of the unique difficulties of his task, but much can be done in every

sphere of life to make that path more balanced, so that, deeply rooted in his people, he breathes their inmost prayer into the work he creates, as well as the spirit of the universe around him.

Wallis, within his limitations, achieved this in some degree, but largely in spite of, and not because of, his circumstances.

But the Tiger as well as the Dove controls our lives, and it would be a denial of the wholeness of our nature to exclude one or the other in our effort towards total expression.

We live in a disintegrating society. It is difficult to make a distinction between what might be, what might have been, what was and what is.

As Nicholson said, we must obviously have "at least Beveridge" (providing it is used properly). And in the further issue we must have much more, the least of which is the birthright of every man and woman to expect the assurance of economic security and cultural development from the moment he stirs in the womb.

The spectacle of starving and crazed artists such as Vincent, Meryon, Wallis must become a thing of the past. The inauguration of a Society of Creative Artists backed by the State should have been a well-founded institution by now, instead of which it does not exist. Yet it is the intense sincerity, through all anguish and difficulties, of a Dostoievsky, a Blake, a Wallis which is at one and the same time a touchstone of the age and light to their contemporaries.

No one individual can be accused for Wallis' plight. The whole situation was the outcome of a long and involved social process, and can only be looked upon as another social crime.

The most I have heard of Wallis receiving was a cheque for £5 for a parcel of paintings. The highest and most reasonable offer was made by a collector who declared he would pay £5 for anything Wallis painted. Wallis was in the workhouse at the time and the Master advised against it, pointing out that the money would go to the Institution and in no way benefit the artist.

Nevertheless it must be realized that if it wasn't for these collectors and artists Wallis' work would most likely never have come to light. In the selection and preservation of the best of his work they have done a good service to art. It is hoped that they will write about and exhibit his paintings, giving him his place as a primitive of modern times.

The fact that Alfred Wallis' cottage was almost next door to the St. Ives Art Society is worth comment for the oddly ironical situation it presents. These artists did not consider him as anything but a crazy old man who passed his time creating rubbish. As one of them said, with fitting pomposity: "I can see no reason for all this eulogy!"

At one time Mr. Baughan and a few friends encouraged Wallis to submit some of his work to the Porthmeor Gallery for exhibition, which, it seems, he

60

would most certainly have done had someone not over-stressed the point and frightened him off. His suspicion was so easily wakened. He knew people laughed at his work. Having great difficulty in keeping his modest and simple faith in what he was doing, he was over-sensitive of being made a fool of.

This is the only time I have ever heard of Wallis seeing any meaning at all in exhibiting pictures. When Ben Nicholson told him one of his pictures was at the Museum of Modern Art, New York, he made no response. Similarly, when his friend showed him a reproduction of *Houses with Animals*, published by Herbert Read in *D'Art Contemporaire en Angleterre*, he said, "I've got one like that at home!" In fact reproduction and exhibition of his work meant absolutely nothing to him; it was something he did not understand.

Paintings by Alfred Wallis were exhibited at Tooths Gallery with the "7 and 5" group, and, later, some at the Wertheim Gallery—both during his lifetime.

9

I have given this book the sub-title "Primitive" with the distinct purpose of reminding the reader that Alfred Wallis, though he lived in our times, was yet a Primitive Painter—as much a primitive as the artists of Altimira, whose powerful vision still comes charging down the ages—and all judgment of his work must necessarily be made with this in mind. The most common obstacle to many people coming to his work for the first time is that it resembles the work of a child, and shows none of those finer niceties of technical achievement which tradition, and ignorance of the proper function of an artist, have taught us to look for.

In a child's painting of a sailing boat, it can be seen how very near Wallis was to the child's approach. When I first saw this painting (which unfortunately I cannot reproduce here) it was so like a Wallis I found it disconcerting. Not only was it direct, imaginative and simple, but at first it seemed to carry the mark of his hand. I was soon to realise that this impression was only superficial. The experience, depth of feeling, knowledge of boats and the sea, were lacking.

The child's painting, done with black and blue paint on grey paper, was certainly alive, fresh and spontaneous, and the experience it transmitted, the vibration, was that of a child: frail, clear, pristine. There was none of the rugged texture, the wrenched paint, the nervous or ropey line, the feeling of the boat being rooted in, yet buoyed on the water; no understanding of the behaviour of the sea and of sails, no angry clouds that thunder like a poet's eyes.

Take the two paintings. Both man and child set out to paint a boat on the sea: both did it in almost the same way. Their minds created an imaginative symbol of a boat: an oblong shape with triangular shapes set above it. In both cases the sky is an area of untouched paper. But in Wallis that area is teeming with hidden life—in the child's picture it remains paper. Superficially, even to the bird-forms, which are identical with ones Wallis often used, the two paintings might be the work of the same hand.

In a child's development, as is well known, there is a "transition" period, which, some claim, begins about the seventh year, but does not make itself noticeable until the tenth or twelfth year. It is then one begins to see the child turning away from its imaginative world, becoming discontented with it, and trying to imitate, to reproduce on paper, a representation of the external objective world around it. For this to happen seems to be a natural stage in the development of the mind, but it is hastened and strengthened in impetus by the prejudice set up by society, parents, teachers, tradition, magazines and a hundred other things. Gradually "the prison walls begin to close about the

growing boy"—the imaginative world is lost, more often than not, for ever. Only the virile imaginative and unusual child is strong enough to resist the influence and get through to mature expression.

What is this imaginative world which we share during childhood with savages and other primitive peoples? Firstly it is the direct, uncensored, spontaneous reaction to *life*. For children the world is One. They live in Eden.

I have spoken earlier of a deeper layer of consciousness from which a few illuminated beings draw their vision and inspiration. This is the Genius of Life. In childhood, the machinery of the intellect not having been assembled and set in motion, this Genius has freedom—and the more free the child, the more freely flows this magic and divine quality. The child's life is a clear and beautiful fantasy, even though its sorrows are as real to it as ours are to us. The whole of life is new, every image and event is a vivid experience working on the child's heart, causing the emotions to leap and rush through its being, creating at every beat of the pulse an imaginative symbol, which is the expression of both what it *feels* and what it *sees*—for the child these are indistinguishable: there is no division between the objective and subjective world. This is what a child paints. The symbols that tumble out of its fingers with such creative inventiveness and delight are the things it feels and sees: the child itself *is* these things. The paradox of unity with life, which presents itself to us dismayed and God-cursed adults as so complex, is, to the child, a simple, vivid and living reality.

It is important to note that Cizek points out that the more intense and imaginative of childhood expression in art comes almost invariably from the children of the poor, to whom the release is greatest, and I would myself add, but with the greatest humility, those to whom there has been given greater play to the *instincts*.

The child needs no technical training or equipment, because the nature and method of artistic expression—the way in which it draws and paints—are a natural product of the Genius by which it lives, and therefore both faultless and adequate. You cannot teach a child to paint, it already knows how: all a teacher can do is to lead it constantly back to the source of its own creative activity, and care for its natural development from one stage of expression to the next.

How much this period of change is an inherent part of the mind's growth and how much it is due to the influence of environment and society is difficult to say, but I am convinced the child could be carried through without losing its pristine contact with reality, at the same time absorbing conceptual thought, and the method and laws, developed throughout history, which underlie painting and drawing. But to consider this here would be out of our field.

What directly concerns us, by way of drawing a parallel with the unusual

advent of a painter like Wallis, is a brief outline of the way a painter of our times must go.

He comes to the gate—through it he must pass. His true spirit is imprisoned in the world of objective fact.

> Man is that prison where his will
> Has shut without pity
> In a clock, eternity,
> In his fist, rose of infinity.

Poet and painter alike are for ever working to reclaim this lost heritage.

Not only the many complex laws and codes of society as such, but also the laws of painting and drawing as they are taught to-day—a method founded on traditional naturalistic painting, usually going back no further than the Renaissance (but, happily, improving)—are the first difficulties to be faced; and in doing this the emotional, expressive life of the heart, the inventiveness of the imagination, tend to be strait-jacketed. On the continent this has been less the case than in England—hence the glory of French art—but as a general rule it is true.

But from the beginning the flash of life caught periodically during development through these laws comes to most young artists as a sense of discovery—"proud Cortez" with his eagle eye, a glimpse of a new land outspread, pioneering work to be done. To them it seems their vocation is God-sent. (Perhaps it is.) Then comes the building up of individual convictions, experiences in art, painting, poetry, coming and going, momentarily starting the deeper rhythms, and its successive beats that will finally come to stay.

The influence of art is at first largely traditional, but when reaction sets in, showing the first restlessness of spirit (that is, if the spirit has not already died under the strain and settled down to the useless reproduction of objective fact for the rest of its days), an interest in world art begins—Persian, Aztec, Chinese, Indian and so on—followed by a growing awareness of creative development since Cézanne. Rebellion ensues. Maybe he is painting a picture like Braque one day, Picasso the next, Vermeer the next, until gradually the waters quieten; the rhythm begins to beat a longer and more constant measure; the artist is learning to draw from his own experience, from his own being and his awareness to life itself.

Parallel to this development in art there has been a continuous development in life in all its external forms. And beneath this upper twin-tumult the stream of creative genius has been flowing, only sometimes making itself noticed. It is through his penetration, both into life and into his own soul, which in its final result is one, that the artist learns to create for himself and the society in which

he lives. His quest is always for the larger Truth underlying the appearance of objects and events.

Once he has discovered how to do this in his own way he is through—the spark lights—but lights now not from a simple pristine reaction to life as in childhood, but from a whole galaxy of experience, emotional, social and intellectual, and the significant image is conceived by the imagination: the symbol of two worlds, creating a third.

The important point to stress now is that during the period of development there has grown an increasing self-consciousness of the intellectual effort primarily, and of the self-creating—something that was not apparent in childhood. It is the curse and weakness of much contemporary or "modern" art, because of the stress on individualism (or the wrong kind of individualism —for a self at last found must be lost in a larger self, which is society and the universe at one). This is the result of a cleft, ill-balanced society, which has forced the artist inwards, at the expense of his finding a relationship with his own inner life and the remarkable radiation of life which surrounds him. But once the artist discovers the Genius that guides him he begins to understand his proper function, and to learn to serve the spirit with humility, sacrificing his precious individualism to the un-individuality of the highest.

The great painter listens to the one voice, even though as a man he may in terms of human relationship behave badly.

For many this is a long quest. Bernard Leach once told me that the potter, Hamada, said he could not expect to lose his "tail" before he was forty.

So we have the child, and we have the mature, sophisticated artist of modern civilisation—both created from the same source, the only difference being that the mature artist has as his heritage the arts of all time and the experience of a complex development. With this larger equipment, and a spirit that has gained strength and tenacity during the long struggle, he penetrates deeper into the mysteries and truth of life.

One cannot state, much less resolve, these difficult problems in so few words. What I have said here is only a general summary of the way in which, very broadly speaking, an artist of our time is more or less obliged to develop. The way for each individual will vary according to his make-up, and the conditions and influences of his own life. It would be didactic and ostentatious to lay down a certain trend of influences as a fixed pattern for every artist. But it is with more confidence that I present the underlying law over which I believe these varying patterns of development play.

With the primitive artist proper, that is, the artist of the cave, the jungle and the open plain—or of the early days of great civilisations—the position is much the same as it is for the child, save that the primitive usually has a strong tradition to work on, from which to draw the strength of centuries. Also he

grows to manhood and experiences deeply the events and objects he depicts. But his vision remains childish (or, more correctly, primitive), for there are none of the intellectual and materialistic influences of civilisation to destroy it, and his instincts are free. Like all artists he takes his place in the community, speaking and working for it.

And what of Alfred Wallis? How does he fit into the construction we have erected? As a result of his curious life he falls, in a peculiar way, somewhere between the three main categories, gathering some qualities from each. He was a man of our times, yet he painted like a savage; he was a grown man with a wide experience of life, yet he painted like a child—as Read says, more *naif* than Rousseau.

It will be remembered that Wallis' childhood was brief and sad: at an age when most children are still living in a world of fantasy, he was earning his living at one of the hardest jobs of his day, as a seaman on a windjammer. He had had no schooling at that time and could neither read nor write. The effect of this, as far as we can surmise, was that his imaginative childhood vision, because it was given no chance to express itself and develop, remained intact; no influence of Art eclipsed it; and although the imagery and attitude of his times largely conditioned his mind, it did not, at least in this respect, affect him fundamentally. He did not lose touch with his early contacts with the Genius of Life. The child remained within the mansion of the man, looking through the windows, searching the rooms for its mother and for a way of interpreting the spontaneous experience that came to it.

As life went on that experience grew wider, deepening his spirit, but the original balance of his emotion and intellect had in no way been altered, at least as regards imaginative vision. He saw things as a child, with the same spontaneity and touching simplicity. True his consciousness of form was developed, true he taught himself to read and write, to conduct a business, bring up a family, and these things had their effect, but must largely be included as experience of life. The genius still flowed, the imagery created in his mind at each moment was the product of his "innocent eye," and fundamentally childish and primitive.

When the time for self-expression came he was in the odd position of having a wide experience, a great receptivity, a large understanding of his own sphere of life, an intuitive comprehension of the universe, but only the technical equipment of a child with which to express these things.

He had practically no influence from Art. It is doubtful whether he ever saw a good painting, and I don't think he would have been able to judge it if he had. His own taste was for those hideous Victorian prints one still finds in the homes of older working-class people, for prints of ships which he got from Mr. Armour's shop in return for a day's work—he used to take these home and

copy them in the earlier painting days—and for photographs. In his work the influence of all these things is noticeable. The St. Ives artists did not influence him—in holding them as a standard of "real painting" to which he was too humble to aspire, he was set free.

"I am self taught," he writes to H. S. Ede, "so you cannot like me to those that have been taught both in school and paint. I have to learn myself, I never go out to paint nor I never show them."

But in his conscious mind he was trying to paint life as he saw it, naturalistically—or rather, realistically—for he was a stern realist, and it was with real problems he struggled.

Mr. Laity, a tea merchant on the Wharf, was one day in Wallis' cottage watching him work on a painting of the harbour. After a little while Wallis paused in his work, looking perplexed.

"What's the matter?" asked Laity.

"Aw," said Wallis, "*that* boat's alright, and *they*—but I der want to paint one sailin' round the head of the Kay into the harbour, you . . ."

He continued to struggle with the problem, until finally he finished by painting the boat "standing h'up on end."

This was a purely technical difficulty, it would seem, but it is often from such difficulties that the enchanting quality of his work is derived. He was always struggling to "get it right." His personal sincerity is hall-marked by the untiring and conscientious effort, but whatever the conscious intention may have been, the deep unconscious levels were pressing upward for self-expression and had to pass through, and to some extent resolve, the conflicting forces in his mind—the whole man always demanded precedence and the significant image triumphed.

The nature and method of painting and drawing, as with the child, was created by the expression of genius. He invented his technique to correspond with his imaginative image and the vitality and meaning with which it was invested. That this did not always succeed is obvious. Many unsuccessful paintings prove it. But at his best it was so.

He was freed from the self-conscious state of individualism—his achievement was largely, if not entirely, *unconscious*—because, with genuine humility, he listened to the one voice.

It has been said that the problem was easier for Wallis than the sophisticated civilised artist, because he did not have to face the complex development with which the civilised artist is confronted. But if we consider Wallis in his *own* context, remembering all the obstacles that beset him, this is not entirely true. His one major advantage was in the fact that he followed a calling which he loved, and a religion (for all its detrimental effects) in which he profoundly believed. Because of this, and because of the preservation of his primitive

vision, he never lost sight of the divine truth in the forests of the ego.

In his article on Wallis, Ben Nicholson says:

"In a recent *Horizon* there was a description of how Klee brought the warp and woof of a canvas to life; in much the same way Wallis did this for an old piece of cardboard; he would cut out the top and bottom of an old cardboard box, and sometimes the four sides, into irregular shapes, using each shape as a key to a movement in a painting, and using the colour and texture of the board as a key to its colour and texture. When the painting was completed, what remained of the board, a brown, a grey, a white or a green board, sometimes in the sky, sometimes in the sea, or perhaps in a field or a lighthouse, would be as deeply experienced as the remainder of the painting."

To my mind this is an excellent description of exactly what Wallis did with a piece of cardboard. The areas he left untouched were indeed teeming with life and significance. When I asked Nicholson whether he thought Wallis did this consciously, in the same way as did Klee, he said: "In my opinion Wallis did this *sub-consciously, not* consciously. Klee also did it (if he did it at all?) sub-consciously: no painting idea can be 'created' consciously—the difference between Wallis and some artist like Klee could be that Klee could analyse it afterwards and Wallis couldn't."

I think that the shapes of Wallis' boards were as unconsciously chosen as the shapes of strips of bark or leather, or the cave-stones on which primitive man painted. And areas of untouched board were as unconsciously felt and organised as any other shape, colour or texture he conceived.

Others have said that the pictorial excellence of his work was fortuitous, and a result of his central innocence and intellectual ignorance—but however true this may at first appear, there was a hidden intuitive guiding force at work.

His paintings came into being from no other source than his own creative soul, as though he had said:

> Where got I that truth?
> Out of a medium's mouth,
> Out of nothing it came,
> Out of the forest loam,
> Out of the dark night where lay
> The crowns of Nineveh.

We cannot do much about placing Wallis in relation to the history of art, only inasmuch as he has already had a certain influence, which will probably increase as he becomes better known. He was one of those odd stems that history sometimes throws off, standing alone, as far as we know, as the Primitive of the Twentieth Century.

At least one good lesson he has to teach—that is, for every artist to be himself and true to his own vision. Wallis' startling inventiveness, control,

selection and organization of texture, colour, form, his instinct for design, his power to communicate the deepest issues of life, grow out of precisely this one thing. The effect of his work on others will probably be (as it has been already) to set them trying to paint like Wallis, trying to be primitive, imitating him; but to do that is to be wholly insincere.

At so close a time it is not possible fully to estimate the value and importance of Wallis' work to mankind in relation to that of his contemporaries. It may be that, being so near, I am seeing him out of proportion—almost certainly I am—he is probably larger or smaller than I judge. But one indisputable fact remains: his work will endure.

Before closing this chapter, I would like to draw the reader's attention to Wallis' *Portrait of a Woman*, the only portrait known to have been painted by him. There is evidence to believe it may have been painted over a portrait already on the canvas: canvasses half-treated in this way and left were found in the cottage. No doubt he used the method as an aid to drawing—or "moulding", as he called it. But the final transmutation was completely into his own mode of expression.

It is interesting to compare this painting with a portrait by a child; or even with another Primitive of our time, Henri le Douanier Rousseau, and with Picasso's "primitiveness", which has grown through the intellectualism of a highly civilised artist. Picasso said of himself: "I could draw like Raphael by the time I was twenty one, but it has taken me a lifetime to learn to draw like a child!" Wallis had not got this problem: he *was* a child. As he said: "I guessed it all".

KNOCKED DOWN BY A MOTER CAR IN THE STREET
BOYS SENT IN THE PATH THAT LEADS TO TREGUNA

10

KNOCKED DOWN BY A MOTER CAR IN THE STREET
MOLISTED IN THE HIGH ROD CIGVEN HILL
BOYS SENT IN A TRAIN
BOYS IN A SUNDAYS MEETIN
BOYS SENT IN THE PATH THAT LEADS TO TREGUNA
AND WATCHEN IN THE STREETS EVERYWHERE
AND NO REST IN MY HOUSE
i HAD TO STAY HOME i COULD NOT LISTEN
TO IT NO LONGER
SO ITS YEARS SENCE
i HAVE BEEN ANYWHERE
AND THROUGH STANS AT MY DOOR
AND AS i OPENED MY DOOR A STAN
PAST OVER MY HEAD AND WENT IN THE KITCHEN
AND IF i WAS A BIT TALLER
IT WOULD HAVE TOOK ME IN THE FACE AND EYS.

This archaic statement is one of two which Wallis gave to Mr. Baughan the grocer about 1936. It records the persecution to which he believed himself to be a victim. It was written in pencil on both sides of a sheet of ruled paper.

Mr. Baughan was very diplomatic in the way he handled Wallis. He liked him, and was sorry for him because of the poverty in which he lived, but he understood the character of the old man's mind and was always careful not to do anything to arouse his suspicion.

"For instance," said Baughan, "I never called purposely to see him. He would immediately have thought I was trying to get something out of him. But if I called with the milk, as I did every morning, he would always have a story to tell—and when he came into my shop for his groceries on a Friday."

Mr. Baughan is a quiet man, with something rather distinguished about his long forehead and well-built nose. His hair is white and short, sticking out on end. Standing behind the counter of his tiny shop where the sand whirls down the narrow Digey to the town, he systematically and very slowly created a picture of Alfred Wallis. I felt that he understood Wallis as a human being and accepted him, just as Armour and Edwards had done. His relationship with Alfred was rather curious really.

For instance, there was a book which Alfred gave to Mr. Baughan "about three times." I think it was originally a present from Ben Nicholson: a large volume on old schooners and windjammers. Each time Wallis had given it he

had taken it back (presumably to look something up), then, quite unexpectedly, he would come into the shop, lay the book on the counter, nod and go away.

"Of course, a lot was taken for granted with the old man," Mr. Baughan went on in his slow voice. "Now—like this. Only once he asked me to give him cardboard. After that I would save up say a dozen fair-sized sheets—like those large advertisement cards." He pointed to some cards in the window, behind a row of empty sweet bottles and shelves of provisions. "When I had enough I'd drop them down by his kitchen wall with the milk, and he'd turn and nod at them as much as to say: 'I knew they were coming!' He greeted the *cards!* if you understand. There was no need to say anything. He had asked me once—that was enough: after that he trusted me to bring them. I myself line all that up with his giving me that certificate of merit about his birth when he first came to deal off me. It was his way of saying: 'I trust you!' Really, giving me the certificate was a compliment."

It was in this way, over a long period of time, that Mr. Baughan built up Alfred's confidence in him—a very admirable thing to have done, for Wallis had little enough faith in his fellow men during the last years. He suffered poignantly from fear and loneliness: there is little doubt that he found comfort in confiding in his friend, even by so strange a method as writing his sufferings with such righteous indignation on the side of a cake carton.

In a letter written to Alfred Wallis in 1937 H. S. Ede wishes him well and hopes he has recovered from his accident. The accident referred to is the occasion of his being "Knocked Down by a Moter Car in The Street," or, as the second script has it, "Thron under Moter Car." In 1936 or 1937 Alfred was knocked down by the Mayor's car in the Digey—the street, adjacent to Back Road West, that leads from Porthmeor Beach to the town.

He was very badly shaken up and was never quite the same man afterwards. His age at that time was eighty-two. Moreover, he was treated shabbily over this. Very little notice was taken by the occupants of the car at the time of the accident, and no one troubled to call on him afterwards to see how he was. In his own mind he looked upon this as another manifestation of the satanic aggression which was destroying his life. One cannot help noticing how oddly symbolic it was that our Ancient Mariner should be knocked down by a modern machine. The external Invader had come right to his door. Obviously people don't go about knocking old men down with their cars on purpose, but Wallis felt in himself this act was malicious.

Let us follow the script again. The second line tells how he was "molisted in the High Rod Cigven hill." Checking this with the second text we learn that he was stoned on the high road one day and on Skidden Hill, St. Ives, which is at the other end of the town—presumably by boys, for without any punctuation (the text is so direct and pure that one might be reading a poem by

a hand that has stretched an octave between Chaucer and some modern poet) he tells how the boys were *sent* (by the Devil) to worry him on a train journey, at a "Sundays meetin'," and on the "Path That leads to Treguna" (Tregenna Castle)—"Watchen in The streets Everywhere." Then the monumental sentence:

NO REST IN MY HOUSE

It is no new thing for boys to throw stones—I have done it myself, though I can't remember choosing an old man for my target. I have not noticed the Cornish children are particularly addicted to this, but am told that a few years ago it was so, particularly at Newlyn. Nor have I any record from an *eye-witness* that Wallis was stoned. But it is fairly certain that children called after him. One man, Matthew Berriman, a fisherman, who is now over sixty, at present working as a farm labourer, has said that he remembers when he was a boy the children crowding round the doors of Wallis' cellar on Bethesda Hill and calling after him.

On one occasion Wallis, in his last years, decided to bathe. He went down on Porthmeor Beach, cut off the legs of his trousers, and was just about to enter the water when some girls began to laugh at him and call out: "Dooty Mighty! Dooty Mighty!'

He never attempted it again.

His favourite walk was along the little footpath that leads past the cemetery where he now rests, through the thick green turf above the cliffs, to Man's Head, Clodgy Point—but this was also spoiled for him by the children: he had to give it up. There is little doubt that he *was* the butt of children's fun, which would have been stimulated instead of lessened by the fact that it made him so mad.

The incident recorded by him of boys sent in a train refers to an occasion when he went to Penzance for the day. He often went there to look at the places he had lived in, sometimes walking both ways. On the outward journey there were some boys in his carriage, who presumably did something to annoy him. Boys have little respect for others in a railway compartment, and they have a particular instinct for the touchy and morose passenger. By some trick of circumstance these boys were in the same compartment on his return journey. Wallis concluded that they were "sent" with the special purpose of molesting him. At Marazion the porters stared at him. He got so wild that he climbed out of the carriage shouting: "I'm not going to ride in your train!" and walked home—a distance of about ten miles. He was eighty-four.

In both texts he also makes a record of boys worrying him in a 'Sundays meetin'" or "serves." This is interesting because it proves to us that he did sometimes attend outside services, and it was very likely the impudence and cock-a-snooting of the boys—who, after all (and quite rightly so), are far more

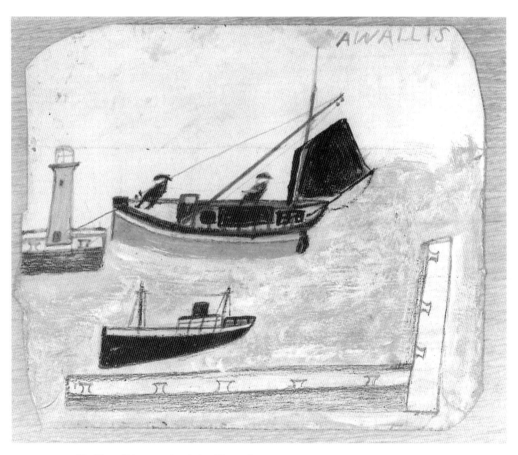

15. *Two fishermen in their ship with one mast stepped*. Oil on card 7½"×8".

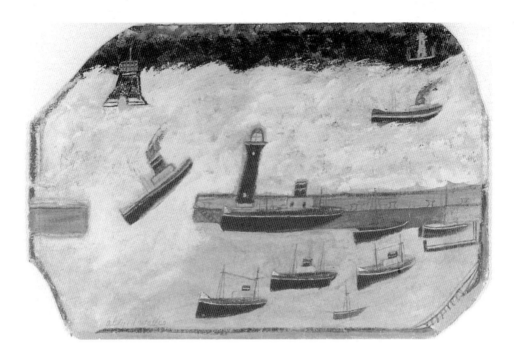

16. *Penzance Harbour*. Oil on card 12″×18″.

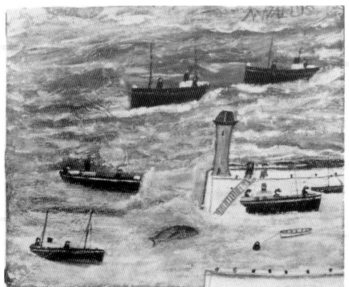

17. *Trawlers entering harbour*.

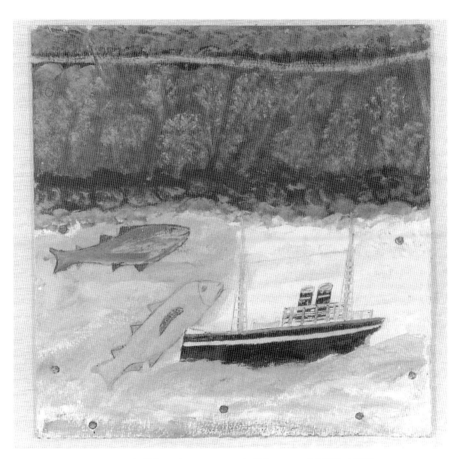

18. *Land, fish and motor vessel*. Oil on card 14³⁄₄″×14³⁄₄″.

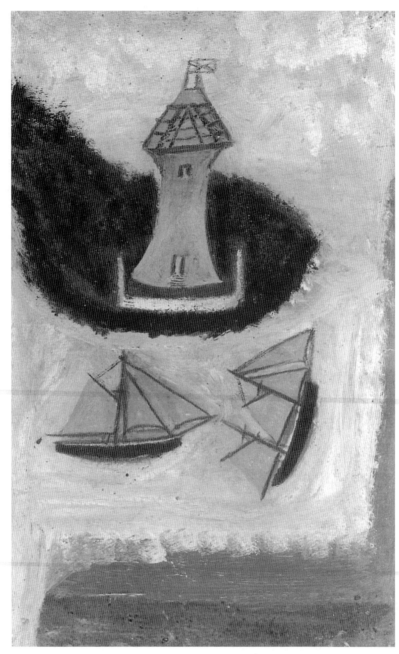

19. *Lighthouse and two ships*. Oil on card 11⅛″×7⅛″.

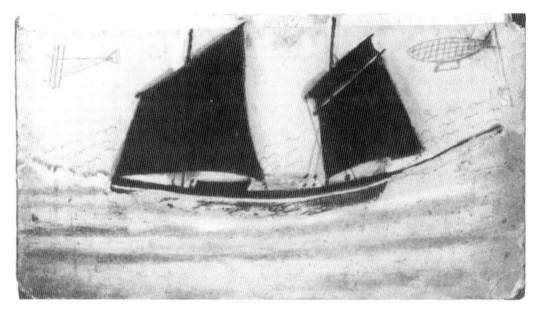

20. Boat with plane and airship.

21. Boats passing coast.

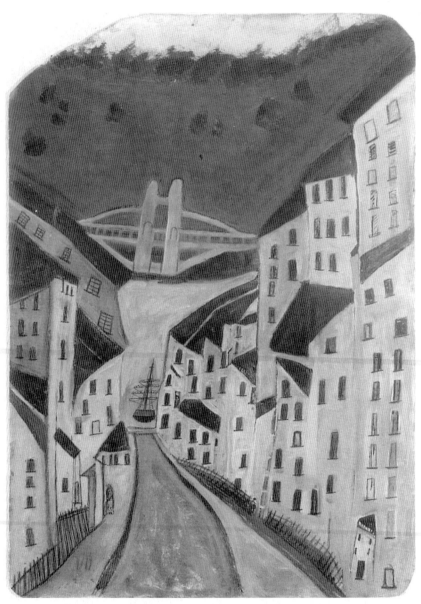

22. *Saltash*. Oil and watercolour on board 29½"×21".

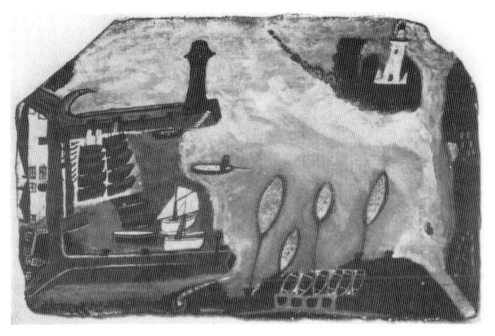

23. St. Ives Bay.

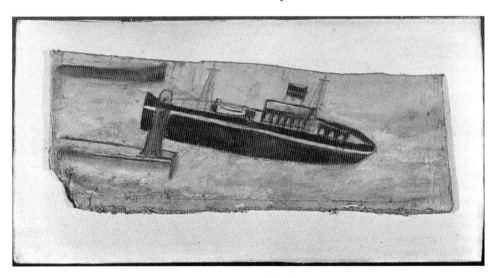

24. Ship passing lighthouse.

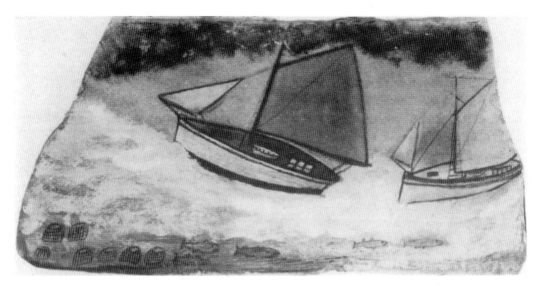

25 & 26. Boats with lobster pots and *Sailing ship and orchard.*

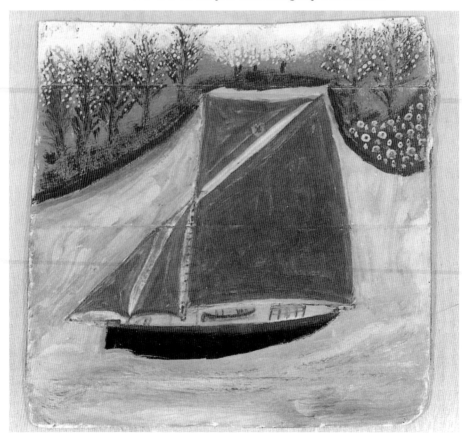

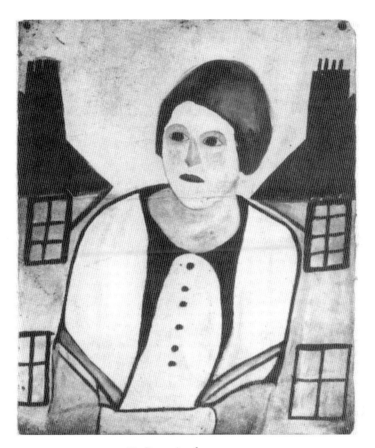

27. *Portrait of a woman.*

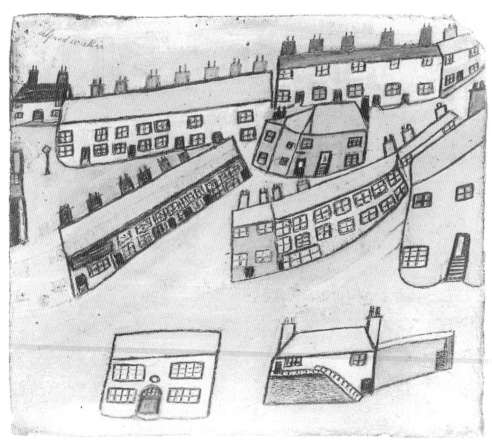

28. *Houses at St. Ives.* Oil on card 10½″×12½″.

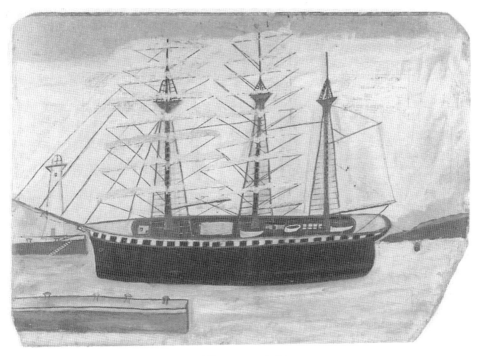

29. Three-masted ship.

30. Three-master in full sail near lighthouse. Oil on card 5½"×15".

31. *Boats before a great bridge.* Oil on card 14½″×15½″.

32 & 33. *Tugboat*. Mixed media 10″×12½″, and *Schooner and lighthouse*.

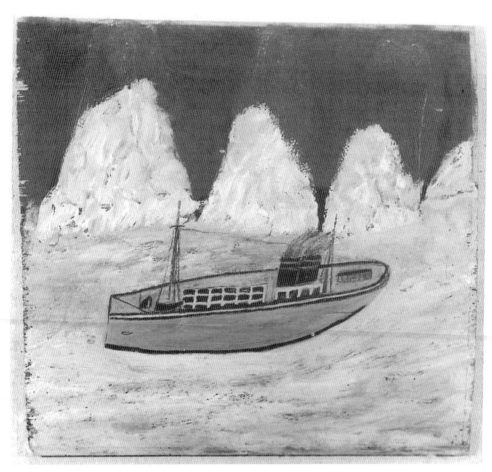

34. *Voyage to Labrador*. Oil on plywood 14½″×15¼″.

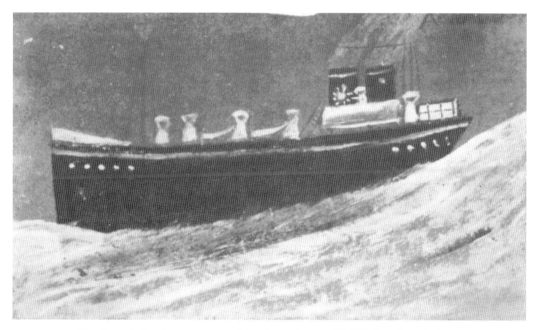

35. One of the pictures grouped by the author as Wallis' 'Death' paintings.

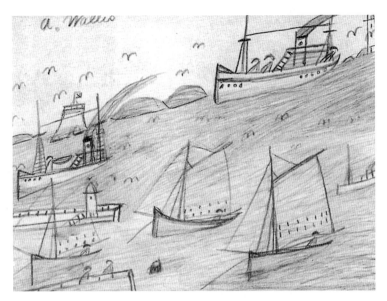

36 & 37. *Ships entering a harbour.* Crayon 10″×14″, and *Huntsman, hounds and house.*

interested in pea-shooters than in God—that helped to drive him to hold his own service alone in his cottage, playing the organ, from which, Mr. Edwards tells us, "he could whack out a good tune."

And finally the attack on the "house." Of this I can supply no details other than the statement written in his own hand.

The little corroboration available to check this account of persecution leads us to the belief that the inner world, as well as the outer, was playing a large part. His fantasy life had built itself up to considerable proportions by this date and he was growing so deaf that it was necessary to write down on paper everything one wanted to say to him. Any accident, any sally of fun from a boy, or unmitigated mischief, would have been enough to set him going. The important thing is what this represented to Wallis. Surely it was the reversal of the curse that had followed him all his life—he was childless, and his step-children (as he saw the position) had ruined him.

Let us seek further. Ask a question. Who was "Dooty Mighty"? First: it was a Woman. But why such an odd name?

"Dooty Mighty"—or, more correctly, "Duty Mighty"—was a female voice which, it seems, Wallis used to obey.

One day he came to Mr. Armour very depressed.

"I ain't gon a paint n'more!" he said disconsolately.

"You old *fool!*" snapped Armour. "Why not?"

"Dooty Mighty says I mustn't paint. She'll give me *hell* if I do."

"Bugger Dooty Mighty!" replied Armour. "It don't matter a damn about *she*. Now you go on home an' paint a pitcher." His voice was commanding, and Wallis obeyed. He went home and painted "St. Michael's Mount, Penzance, the Longships, an' all the bloody lot. Wonderful. Best painten I ever see. We sent it to the Tates Gallery" (probably to H. S. Ede).

When Mr. Armour had told me this, standing one day outside his shop, he stood for quite a while with his hands in his pockets:

"Of course, the paintens, they wasn't in *reason*," he said later, "but these artiss fellers thought they were good. You see—'e guessed it all—'e guessed it!"

Armour then said to me: "You go in to Mr. Edwards and ask en about Dooty Mighty; 'e'll tell 'e all about en!"

This I did immediately. Over the gentle ticking of the clocks, which was like the whispering of leaves, the watchmaker told me how, many summers ago, there was a Boy Scouts' rally in St. Ives. One day the Scouts were in Back Road. Wallis thought they were after him. He shut himself in his cottage, bolted the door and peeped through the curtains at them for the rest of the day. They were sent by Duty Mighty.

According to Mr. Edwards there was another spirit whom Wallis called

"Colonel Benson." This Colonel had a daughter whom he was always sending after Alfred. That year a fun fair was held in the Island. In the evenings the people would congregate there, coming home late at night by way of Back Road. They were sent by Colonel Benson. Again the door was bolted.

But it was Duty Mighty who held dictatorship on Wallis' mind. She controlled and regimented the spirits, ordering them to pursue him. Perhaps it was an extension of his wife's voice—I am almost convinced it was—though it is not possible to tell what image went with it.

From the point of view of psychology one is placed in a position of supremacy over the minds of other people. The symbology can be interpreted and the writer can say: This was *so!*—in spite of the fact that the person in question, if alive, may vigorously deny it. It is a dangerous position in which to be—so easily one can be led into error and fabrication—and this is the last thing a writer, with a grain of sincerity left in him, wishes to do. For my own part, I have only one intention and hope in writing this book: to make clear the personality of Alfred Wallis. That this is partly entangled with interpretation of life, particularly of *his* life, is largely unavoidable, and one can do no more than cast a trembling mirror, which, with countless distortions and inaccuracies, will reflect a semblance of what he was at different stages in the process of Becoming. Historically, psychologically, economically and spiritually, these distortions exist.

On this basis I make the suggestion that Duty Mighty *was* Wallis' wife, though I don't suppose he was aware of it.

There is no need to repeat the facts about his father and mother, his childhood, marriage and lack of children. We know what was demanded of him, and Susan, "a very human Mrs. Wallis" as someone has said, with her vigorous, kindly, dominating personality, kept him at his task of breadwinner for her large family. It was his *duty* in life. Susan looked to her children first—it was her instinct to do so—and in later years helped them through hard times. Albert, for instance, had a baker's business: he went bankrupt: it was Susan who put him on his feet. Jacob, when his first wife died, was left with several children: Alfred and Susan gave them asylum. Then there is the story of the gold stolen at Susan's deathbed—however inaccurate the facts of this tale may be proved, it is certain there was nothing left for Alfred afterwards.

He turned against the Wards.

Having made this rapid summary of his life, let us recall the other things at work in Alfred. In earlier pages I have tried to show how closely interwoven with the peasant's mind are the economic and religious problems, how, basically, they find a common root in the fear of extinction and the love of life, and how political and economic conditions during the years Wallis lived drove him into a disciplinary framework which was gradually being forced apart both

by the further development of civilisation and the flame burning in the depths of his own heart. How, sexually, he was unsatisfied. How all these things rocked and strained at his mind and finally overthrew it.

His love of God was his love of life and the deepest spiritual experience; his fear of God was fear of extinction, fear of the Devil—God and the Devil are one.

Susan, in whom he had longed to feed all the longings of his starved body and heart, became the centre-piece of his economic duty in this world. She dominated, *was* his *Duty Mighty*—*Mighty* because she represented not only the fear of his own extinction, but that also of his own mother, the very creative source from which he sprang—the "Primal Mother," if you will—whilst he himself was vainly trying to compensate for his own loss by being the "Primal Father"—finally worked out in his painting; the very love which created and bore joy and suffering into the world, and was, in fact, his Reality.

But all the time there was what my friend George Manning-Sanders aptly called the "Satanic Majesty at his elbow."

He sought God through the Bible, in the Word:

"i Tell you what i am a Biblekeeper it is Red 3 hundred sixty times a year By me and that is averyons Duity," he writes. And he meant it.

His prayers, his exaltations and worship he painted on the cardboards left against the kitchen wall with the milk by Mr. Baughan. To read the Bible was his spiritual duty; to keep Susan and her family safe from extinction was his economic duty. But to paint was the expression of his entire soul, freeing him from tyranny and destruction. At the root these duties were closely interwoven, just as the voices speaking to him in his cottage, those sent down by the Devil from the room upstairs, were mingled with the voice of Duty Mighty, who commanded him not to paint, and, in league with the Devil, caused the malicious little boys to surround his house and pelt him with stones.

Alfred was influenced by Susan's vigorous evangelical attitude to religion, but his own belief was primarily unorthodox and contemplative, even though, during his hardest times, he always saved his pension and gave it to the Salvation Army in Self-Denial Week; and he asked for an Army burial.

It is clear how very necessary Susan was to Alfred's life, how much he needed her, in spite of the effect it had on him. When she died the last strut of the scaffold that had held him together for all those years fell away.

It was in the remaking of his life afterwards that he finally fixed the centre-piece as his own personal belief in God, balanced by the painting: the Genius of Life flowed through him—but at what cost? For so long he had depended on the external discipline of life which had held back his creative forces from expression, and now this deep-seated need, coupled with violent hatred and

fear, set itself up as a fantasy, taunting and persecuting him. This fantasy became operative in both the subjective and objective worlds, was in fact a merging of the imaginative and material life.

He had turned once and for all on the inward path, toward God and the Unknown. His material and terrestrial existence was disintegrating rapidly. This side of him, as it died, was alive and violent enough to be in terror of hell-fire and damnation, and filled with the bitterest revenge. Hatred at first expressed itself against the Ward family, who eventually became any boy or girl, any adult, and, finally, all society and all religious bodies, controlled by Duty Mighty (the spirit of his dead wife) and the Devil, who lived together in the room upstairs, with their diabolical wireless set. Even *they* created children where he had failed. The Phallus was Unholy.

Now we have some idea of this tormented man, and in what way he spent his nights with the spirits; how they visited him, as they visited Faust, and the agony of contending with something he did not understand.

Whether the voices were accompanied by images extended in space, as in the case of William Blake, who saw the angels moving and singing among the reapers at Sydenham—who, in fact, saw all the Hosts of Heaven and Hell—I don't know. Probably they were.

Visions—"Loozhuns" as the Cornish call them—are fairly common with the very old or very lonely—illiterate people especially.

I knew an old man named Madron (or Madern) who worked with me on a farm at St. Ives. He was subject to these visions and I had ample opportunity to study them. His job was to set out potatoes in trays to shoot. All day he was working alone in the barn, and we could hear him talking to the spirits he projected around him. "Four old women laying on tatey bags, their faces all rigged up like real," and tall men who stood against the wall talking to him. The interesting thing is that, like Wallis, he was very deaf—"stiff of 'earin'" as he put it—and since the images were projected in space before him, through his bodily eyes (which one would have said was totally impossible had he had any *visual* disability), I could not at first make up my mind whether the *voices*, coming back to him from the outer space, whence he had thrown them, passed through the terminus of his ear or not—just as the images passed and repassed through his eye. Finally I remembered an experience in my own life, since checked with other observations. I had a visual illusion—apparently external to myself—which remained vivid and real even though I opened and closed my eyes, the lids acting as useless shutters batting up and down, in no way interfering with the image on the far side of the room. I concluded that this too would be the case with Old Madern's *hearing*, and subsequently decided it to be true of Wallis also: his deafness was no obstacle to the reality of his visions.

There was no escape. Once the curtain was lifted and the diabolical drama

had begun he had to see it through. No wonder his face was drained of blood, breaking out all over in a cold unearthly sweat. No wonder he held his head, shouted, raved, demonstrated in his little kitchen far into the night. This is part of the appalling tragedy of Alfred Wallis' life, and what I have called the incalculable crime of modern society.

No sound is more poignant, more macabre and terrible than a human voice moaning in the night.

Often he woke the neighbours.

At two o'clock one morning in 1938 a policeman passed on his beat down Back Road West. Seeing a light in the window of No. 3, he looked in. In front of the grate he saw Wallis, crouched up warming himself by the fire, smoking his pipe. On the hearth lay the big bellows; the edges of the few pieces of furniture were illuminated by the dull light, casting large deep shadows over the walls. Everywhere there were papers and books. The old man was jabbering to himself. His face was sweating. The spirits had just left.

In the silent street there was a click. The policeman swung round and at the window of a house on the opposite side of the road he saw the white forms of two women in their nightdresses. He went over and commanded them to open the window. Inside the room there was a shuffling and bustle while the women wrapped blankets over their shoulders, and the window was opened.

The policeman enquired about the old man over the road, asking who he was.

"That's Mr. Wallis," they told him. " 'E waiken'd we up with's raivun, yough. We was jus' lookun to see what 'e us doin'. Ay's offun like that, but quite 'armless, mind 'e. The door is h'opun—'e never der lock en—but tas no use you goun in: 'e'll only tell 'e to clear out."

The policeman was satisfied with their explanation and went his way. They closed the window. Across the road Wallis climbed into the old wooden box which he had fixed on the settee to serve as a bed—as far away from the fire as possible, because of the spirits that came down the chimney—curled up and went to sleep.

In the morning, about 11 o'clock—as she did most mornings during those last two years—Mrs. Peters, in a white apron, her arms bare, came out of her cottage to look through his window, holding her hands each side of her clear grey eyes to cut out the reflected light. Wallis was usually kneeling down making the fire or lying awake in his box. If he was awake she would go in the front door.

"Let me boil up yer kittle for 'e, Mr. Wallis, it won't take a minute on my gas-ring!" she said, for she also knew he had had a bad night.

Sometimes he would consent, sometimes he would not answer—but he was always able to understand everything Mrs. Peters said, in spite of his deafness.

"I would go out there in the middle of the day an' look through's window agen," Mrs. Peters went on, repeating the action with her hands, "an' there ud be at 'is table in's white apron, painten away." She imitated him using the brush. "An' sometimes it wud be h'ever s'long afore 'ed look up. I kep tappun, 'e know, but 'e wus s' *deaf*. Then I'd point to the door an' 'ed understand, an' let me in.

" 'I got a bit'a dinner for 'e in there, Mr. Wallis—shall I bring en in?'

" 'Naw! I don want take nothun of *you*, you can do with it y'self!' 'e say.

" 'But can't 'e *eat'en*, Mr. Wallis?'

" 'Yes—I can *eat'en*, yough, but—waal . . .'

"An' in ther h'end 'ed 'ave en. But he allus paid for en mind 'e—give me sixpence, or whatever it was.

"But 'e *was* difficult. If 'e saw a strainger, or one of they Wards, at the window 'e wouldn't let en in. 'E allus said they was after what 'e got. It was a sort of *feelin'* 'e 'ad."

Mrs. Peters dragged both hands over her chest.

After dinner he usually went down to talk to the watchmaker. The moods following these appalling nights often vented themselves on his friend. As time went on he grew more aggressive and awkward. Mr. Edwards says he would sometimes go into the shop and "abuse me wuss than a pickpocket," accusing him of sending messages.

" 'Now look *here*, Alfred,' I told en, 'if you don't tell me who told you I bin sendun they messages over, I'll go an' see the Sergeant!' "

The old man fussed off out of the shop, but in an hour he was back and apologised.

Even at this period, when he was over eighty-six, he would work occasionally for Armour.

"*Active?* 'ed move furniture like a boy. And *walk!* walk Penzance! I can see en now—allus 'ad 'is trousers too big: 'e didn't care; rolled the buggers up; a fisherman's jersey and an ole cap, goin' along the road there with my handcart. *I* couldn't catch't en up. Deaf an' all—'e couldn't hear me shouten. One day I chased en all the way to Carbis Bay!"

Wallis borrowed money from Armour, but only once. Next time a cheque came he insisted on paying it back.

" 'Now you keep the money, Alfie,' I told en, 'an' go and have sump'n to ait, an' put a little by!' Which way he used to live *I* don't know."

Even when Alfred was drawing his pension the local council—delectable body of men—summoned him for failing to pay his rates. This worried him a lot and he used to go to his friend with the summons and tell him about it.

" 'But you're not going to pay *that*, Alfie?'

" 'They'll gimme *hell* if I don't!'

78

" 'Here—give it me!' an' I took't en away from en and wrote Town 'all!' "
Armour grew very indignant.

"*Why*! they ony put en in Work'ouse because 'e tried for h'extra penshun.
Por old man. I arst en to come an' live with me but 'e wouldn't.

"Then, Christmas I took't en a parcel. But it was no good. Giv'd it away.
Thought I was tryin' to paisun en see.

"But 'e was a good old feller: 366 days in the year he read 's Bible. He used to
say to me: 'Do 'e know, Andrew, all this slaughter an' things flyin' in the h'air,
tis all for nothun. Men 'ave got above God's power. They think they're goin' to
show en sump'n . . . but 'e'll *punish'n!*' "

Wallis must often have irritated his friends. He was cantankerous, and they,
in all fairness, were hard-worked human beings. One may suppose that
indifference and impatience found a temporary lodging in their hearts.
Neurotic people are trying to the most temperate natures. The things they did
for him were genuine and real enough, and must have been a comfort, but long
tracts of time passed when little or nothing came to him. . . .

Now and then he was visited by admirers of his work. Ben Nicholson, by now
living in Carbis Bay, continued to send people along—also Adrian Stokes—and
paintings were sold occasionally.

On the annual Show Day in 1941, when all St. Ives artists' studios were open
to the public, it pleased Wallis very much that Peter Lanyon, Nicholson,
Barbara Hepworth and, I think, Gabo, called at his cottage to see his work.
They were his only visitors on that day.

11

The reasons for the maladjustments of Wallis' personality are so many and so complex that the deeper I penetrate into the problem, the more I begin to feel that a satisfactory solution is as far off as it was at the beginning—receding before my fumbling advance.

Comparatively little is known about him, and although the facts we have are "in character" pointing in this direction or that, we would still like more information regarding the years prior to his marriage.

And however much we might read from a completed picture of his childhood, there would still be the pre-natal period, swaddled in mystery, and beyond this the endowment of heredity to assess and classify.

As we come towards the last voyage of Alfred Wallis, which he recorded in the Death Paintings, I become more aware of these difficulties. The only satisfactory answer to the entire problem, to my mind, is found in the fact of his urgent need for self-expression (which I believe is the need of every man and woman—not merely the property of artists). Artists are those who, in greater or lesser degree, achieve the act which leads to the fulfilment of this need.

"Self-expression," like "genius," is a hackneyed and misunderstood phrase; so is "self." The Genius of Life, which I have already postulated, can be identified with the Chinese conception of the "rhythmic vitality of the spirit," which is both within us and external to us. The Chinese remark: "Rhythmic vitality is present and in man only when his spirit is in harmony with the Universal Order." I would venture to say that the action of this quality also *promotes* harmony, just as a state of harmony and equilibrium induces the rhythmic vitality to flow and to be communicated.

Self-expression, then, in its true and deepest meaning, is the expression of that Spirit which is Universal.

In the processes of expression—especially in the Western World—the ego interferes with and conditions the subsequent result: *but the creative act is not primarily the expression of the ego.* The ego is subservient to the spirit in all the greatest art. The manifestation of the spirit amid ill-balanced social and cultural conditions produces a conflict both in society and the individual, because it cannot find free and adequate expression.

"Whatever man cannot express in creativeness he expresses in destruction. . . . Destructiveness is the need for self-expression thwarted in the outside world and turned against its own roots. . . . Only those who are thwarted in adequate self-expression, and are unable to make normal love contacts in the world, are

craving for superiority, or, conversely, for being swallowed up in a bigger whole." So wrote Frank Borkenau in a *Horizon* article.

This "thwarted need for self-expression" existed in Wallis' life for seventy years, and indeed turned against its own roots, and had already driven deep before he found a way out. This psychological process works clearly in the Celtic races, especially the Irish and Cornish Celts. Intermarriage and incest (also the fear of incest) which have existed in Cornwall for centuries no doubt contribute strongly to this (and in turn are probably an expression of it). In natural consequence they accepted their religions—Primitive Methodism in Cornwall, Catholicism in Ireland, Calvinism and Catholicism in Scotland. The overwhelming forces governing their lives have driven them to seek refuge in self-abasement and self-immolation—to submit to the psychological effect of their religions, as distinct from the spirit of the religions themselves.

From this standpoint Wallis' work was opposed to his religious outlook, though the fundamental spirit which emanated from the practice of both—far more vividly in the painting than in religious ceremony—had a common source. Religion stood mainly for the destructive forces at work in Wallis; his painting was a creative effort.

The two practices were separate in his conscious mind, though they influenced one another. If you had called on him on a Sunday and had been lucky enough to gain admittance to his cottage, you would have found no sympathy if you had come to talk about painting. On Sundays all the paintings were covered over with newspapers and put away. Wallis himself would most likely be found sitting at the table with the Family Bible, reading it through a magnifying glass. His conversation was on religion, his thought also. No doubt he would have treated you to a powerful sermon, studded with quotations from all parts of the New and Old Testaments (which he knew by heart), and advised you on the skilful strategy of the Devil. The naïve and patent sincerity of his belief, and above all the constancy of his practice of it, made what he had to say uncomfortably real. And, as Manning-Sanders has observed, for all our advancement in thought and civilisation, how do we know he was wrong when he indicated the Satanic Presence? Were not the demons peering over the shoulder of the Tibetan artist, described for us by Madame Alexandre David-Niell, also real? "All I believe is true!" saith the poet—and perhaps this is the answer to a good deal.

Wallis regarded it as sinful to sell a painting on Sunday and flatly refused to do it—"not for twenty pound." The Sabbath was a day of rest, meditation, and prayer. Until quite recently, farmers in Cornwall—particularly smallholders in the more remote parts—would sooner lose a field of hay than go out and save it on Sunday. In no way must anything be done to rouse the wrath of their tyrannical and jealous God. [I have since learned that he allowed Stokes to look

at his paintings one Sunday, some of which were taken away; but the money had to be sent round another day.]

Wallis thought the cinema to be a house of evil: the belief was so strong with him that he was of the opinion that even those who stood outside were contaminated and should not be touched. This, of course, is the attitude of the Salvation Army as well as the Primitive Methodists as practised in St. Ives to-day. In their minds the cinema is identified with the house of iniquity, the brothel, the place of pernicious pleasure, pursuit of which leads to hell and damnation—and the most intelligent of us can say that this is largely true. It is interesting to record, however, that the Salvation Army granted permission to their flock to go and see Bernard Shaw's *Major Barbara* when it came to St. Ives in 1942.

Problems such as this have a moral basis, founded on a primitive fear of the Unknown—indicating continually the closeness to death in which these people live. It may not be an exaggeration to say they have a *death consciousness*, which plays an important part in their lives, and finds an outward expression in the depressing black garb of the St. Ives women.

The Cornish have a love of funerals, which they still save for Sundays, advertising them with little black notices nailed up about the town, and walking in long, black, solemn processions behind the coffin on the appointed day. Even the architecture of cottage and chapel overhanging the narrow, cobbled streets is impregnated with the perennial ritual of death. The silence and the unmoving countenances of the mourners are impressive.

The deep and terrible tragedy that hit St. Ives in 1938, when the lifeboat was called out at night in a raging north-west gale (the worst since the north-east "Central" gale of 1890) and was driven across the Bay to be shattered on the rocks at Gwithian, leaving only one survivor, illustrated, both in the event itself and the effect it had on the people, the true texture of the *realism* which has been the quality and grain of the Cornish life through the centuries. At such moments the profound need which their religion has been to them becomes apparent. I shall never forget the gravity of the mourning town and the atmosphere of unholiness having passed through the streets like a wind, leaving them still and empty.

Wallis was so upset by this event that he saved three weeks of his pension—his only means of livelihood at that time—and gave it to the Lifeboat Fund.

It is precisely this realism that has bred Cornish austerity, and consequently the austerity of Alfred Wallis' painting. Cornish colour, for instance, grows out of this, as much as it grows from the perennial influence of the rugged lugubrious landscape that has been the backcloth against which their race has enacted its tragedy. The macabre greens, blacks and sullen browns with which

they paint their boats are as natural to them as the grass burnt by the sun on Zennor Moors: they are part of their moral religious thought and literalness of mind.

So it was with Wallis. His colours, though conditioned by lack of materials and limited knowledge, were at the same time controlled by a puritanical and priestly eye, which gave him a great simplicity and faithfulness of observation. Black, green, white and ochre, occasionally introducing pink or blue, were practically all the colours he used, and he seldom used more than three of these at once. The foundational, natural colour of the ground he worked on (as already noted) was always used to the best advantage: some of the results, for instance, arising from the use of black and white oil paint on brown or dingy yellow cardboard are astonishing.

It was nearly always his practice to paint the sea grey or white, pointing out that if you took a glass of sea-water and held it up to the light, it was not green or purple or blue but *colourless*. This attitude was not only literal, it was also scientific and philosophical.

He was *literal*. This word characterizes the man's work right through. Even his obstinate choice of ordinary ship's paint as a medium was illustrative of his literalness of mind. In the same way he read his Bible and believed in the Second Coming not as a poetic truth but as a literal fact, even to the Heavenly Host descending amid the blast of trumpets.

In a scene with fishing boats or trawlers, he painted lobster pots and large fish the size of dinghies, supposed to be below the water: they were *there*—it was a factual representation of an economic need, and they lived with a rhythmic vitality of their own. There was no nebulous emotion or muddled thinking about Wallis. He was a stern realist.

To paint the reflected colour of the sea was to paint the outward scenic show, in which he was not interested. He understood his Bible when it taught him: "Charity vaunteth not itself, is not puffed up."

The analysis of his mind cannot be clear cut: all these divisions I have made are only arbitrary and tentative, useful in discussion. It can only be said that his daily life and his art were closely related within the structure of his moral and religious thought. It was by means of setting up for himself a disciplinary framework and by ceaseless application—to achieve which, in one way or another, is a task for every good artist—that he was able to communicate those elemental qualities of which at root we are all part. It was in this deeper thing that he touched God.

An artist is a nerve-centre of his age, a focus-point of awareness for the society in which he lives. This was true of Wallis. In his work he told the story of men at sea, facing its dangers, enjoying its benedictions of beauty, of peace, of meagre economic reward, of men working in a well-ordered community

until it was squeezed out of existence by the gradual progress of modern politics and finance.

He gave us also the entire peculiar *otherness* of life at sea.

With a poet's imagination he creates for us new images, forms, carrying new experience and meaning, which are, however, strangely and deeply familiar, bringing once more into the stream of human development a solution to the problem of reconciling the imaginative and material worlds of becoming, charging them with the same force of life, so making for us a larger consciousness of life itself, and revitalizing the stream of human creative endeavour.

The fact that this achievement was mainly unconscious is the greatest and most significant part of it, because, at the dissolution of an epoch, the hunger for life expressive of its root-spirit makes itself felt, and it is precisely in unconscious art—primitive, naïve—that contemporary artists have found the strongest stimulus; and also because Wallis was always subservient to that spirit.

His life was a religious discipline in a real sense, and in its final reckoning, a sound proof of the value of inward self-realization as a way of rendering lasting service to society as a whole—in doing this he was able to render rightly unto Caesar and unto God—the outward self was destroyed.

It is on such achievements as this that the value of a man and a nation may be ultimately judged. But for such a one—our humble Ulysses—there is no reward other than the lamentable gifts of the Board of Guardians and the homeless comfort of the workhouse infirmary.

Such tragedies have been enacted too many times in history to be excusable. That the expression of our human genius is not recognized at close quarters is often true, but not so with Wallis. And why should a man be an instrument of genius in order to claim his birthright to live? Whose duty can it be but that of the State and Society to keep such men as Alfred Wallis from poverty and mental anguish? In the great struggle to preserve our ancient heritage we forget the very source from which that heritage springs—the human heart that is beating *now*, and is the pulse of the race.

12

When Alfred Wallis left his nephew's house and returned to his own cottage he said that he refused to leave his fireside. This act was typical and fundamental. His pride in doing this counted for much: it stood for the things he most deeply loved—painting, the sea and the home—which were the symbols of life and of life unending. But soon these were to be taken from him.

He continued to work on in his fleas and filth, eating little (two 2½d. loaves lasting him a week, and his grocer's bill—including half an ounce of twist tobacco, which he smoked and chewed until it gave him heartburn—seldom came to more than 4s.), doing his own washing and cooking, save when help was given by Mrs. Peters.

There is one point about the washing worth noting as we pass. Wallis used to wash out his vests and hang them in the attic to dry. The attic must have been the room in which his wife died, since there is no other upstairs room in the cottage, and therefore we must assume that he did go into this room sometimes by day, which makes the general report that he did not enter it after his wife's death not entirely true.

When the vests were partly dry he would put them on to finish the process.

William Wallis, as I have said, was at least on speaking terms with his uncle. To make further investigations into the nature of their relationship at this time would be to interfere with the private lives of living people.

When his nephew called he used to take the old man a copy of *John Bull* and the *Daily Express*—this was usually on a Saturday. Only once he made the mistake of calling on a Sunday, and taking a Sunday paper to read, which in his uncle's eyes was almost blasphemous.

By the books of Wallis I have come across, it seems he read a good deal, though all more or less in the same field: *The Juvenile Instructor and Companion, Whittier's Poetical Works, Pilgrim's Progress, Light*, by J. F. Rutherford, and the large black *Life of Christ* mentioned by Nicholson. The Bible, however, remained *the* book: time and again he would tap it with the ends of his fingers and say—"Follow this, my boy, and you can't go wrong."

When his nephew went to see him Wallis wouldn't say much. Then, without ceremony, he would take a newspaper from a pile of paintings and ask: "What do you think of they?" and show them one by one.

One day—William Wallis dated it in November, 1940—he lifted a newspaper spread over the surface of his work-table and revealed the marvellous table painting to which I have already referred. His nephew, whom I believe was rather sceptical of Wallis as an artist, was evidently impressed by this.

This association continued until 1941. It was then that William Wallis made an effort to get the Supplementary Pension for his uncle.

Wallis himself was beginning to fail noticeably. Little work was done during these weeks. He stopped going out altogether. One afternoon the watchmaker and the antique dealer decided to go round and see what was wrong. They found the old man in his box fixed to the settee. His face was black. The doctor was called in. Wallis had bronchitis.

I have not had the opportunity of checking with Dr. Matthews, but am told that, finding Wallis in such a state of destitution, quite unable to look after himself, he reported the case to the authorities. Mr. Armour, William Wallis and others are of the opinion that the Pensions Officer did likewise, for a few days after he had been, another official called on Mrs. Peters to say that he had been knocking on Wallis' door but could get no answer.

"'Are *you* the man from the Supplementry Penshuns?' I arst en. 'No,' 'e says, 'I'm the Relievin' Officer!' I knew what *that* meant: poor Mr. Wallis would aff t'go into the Infirmary.

"'H'all right,' I say to en—Mr. Cleveland or Clifton s'name wus—'You come wi' me. The door is opun, an' I'll follow 'e in. Taz no use you goin' alone, 'cause 'e won't 'ear a word you say, and will mose likely tell 'e to clear out.'

"So we went in, an' there was the old man by the fire.

"'You goin' 'ome, Da?' I say. He waited a bit, an' then:

"'I dunno nuthun about tha'!

"Now that's all 'e said—an' turned away.

"'Well,' says the Relievin' Man, 'we'll leave en be till tomorrow.'

"Now that was a Toosdey. Wensdey 'e called on me again.

"'Well,' 'e arsts, 'what's the old man say?'

"'Well, do 'e know, Mister,' I told'n, 'I ha'n't heard'n tell nuthun on that sinz you went away yesdey.'

"'Alright, I'll go in an' talk to en,' says Mr. Clifton—and do you know he was back in a minute.

"'Alright, Mrs. Peters, the old man's made up's mind. I'll bring my car back at six o'clock this evening to fetch him.'

"Why," exclaimed Mrs. Peters, "I never 'ad such a surprise in my life!

"'I know where I'm going,' Mr. Wallis said. 'They're going to take me to Madron Union—that's where I'm going.'

"'Well, you don't mind, do 'e, Mr. Wallis?' I said.

"'No, I don't care *where* I go to be looked after!'—that's what 'e said, Mister, 'e was that glad.

"All the day 'e was dressin' ob'n self. He put on the best 'e'd got: clane underclothes, an' everything, and had a good wash down—until it come avenin'—an' there 'e was, sitt'n there.

" 'You'd better put yer socks on,' I tell'd en. Mind you, 'e 'ad's *shoes* on, but no *socks*—but no, 'e wouldn't.

" 'Not gun 'a put they on,' 'e said, 'not tell 'e *come!*'—an' so 'e sat there.

" 'D' y'know,' he kep' sayin' to me, 'I can't make my mind whether to take that Bible or not. Tas a bit *big*—but, waall . . .'

" 'You can if 'e mind to, but I shouldn't,' I tell'd en. 'They'll suit 'e down with a Bible in there, Mr. Wallis. They'll suit 'e down. Tas too big to take with 'e.' So in ther h'end 'e leaved un.

"All 'e took't with en was 's scissors to cut 'is nails with, an' s'*glass*—he didn't have spekletuls, but a magnifying glass he held tooz h'eye—like this."

Mrs. Peters made a circle with her finger and thumb and held it to her eye.

"Then, as he was goin', the Relievin' Man sais: 'Don't 'e forget your watch, Dad!' an' pointed to the little ole silver watch he had hangin' there on the mantelpiece. So 'e took't that an' away they went—and that was the last I saw ob'n."

Apparently there was also a valuable gold watch which had been in the family for years. It is supposed Wallis sold this during hard times.

So in June, 1941, Wallis made his last journey over the moors, in the cream-coloured saloon car belonging to the Relieving Officer, to Madron, where almost a century before his wife had come from Devon to work for the Bolitho family. At that time the workhouse had been a modern building, no more than a few years old. The date of its erection was 1837.

A soldier from the North of England said to me the other day: "Facts, man, facts! A fact is a lie and bloody arf!" This seems to me to hold a good deal of truth—perhaps far more than the soldier realised. All through this book the most pressing need has been for facts. Yet even when they have been abundant it has not always been possible to dismantle our problem and find a solution. But such facts as there are must be sifted and used.

Towards this point in Wallis' history I am inclined to think that he not only foresaw the possibility of entering the workhouse for some long time before it occurred, but was aware of it as a living, inescapable reality moving towards him.

The fact that Mrs. Peters tells us with such evident surprise that he knew where he was going, even though they hadn't told him, supports this view. The nature of his interview with Mr. Clifton, the long morose silence, charged with fear and pride that one feels so intensely after Mrs. Peters' question: "You goin' 'ome, Da?" is the key to the mind of a man who has watched his destiny for years.

The fact also of his long exposition to Barbara Hepworth and Herbert Read, about the Poor Law and pauper's grave, when they called on him one day, which, Barbara Hepworth tells me, was "simply magnificent—just like an

epic poem!", is also indicative of the centre around which his emotions often grouped themselves. There is no need to reiterate the principles and events that forced him in this direction, and created the anguish he endured as he advanced on the inevitable voyage.

It is even possible he made up his mind to go before the application for his pension was put through.

Stokes called to see Wallis a week before these inner forces, inter-acting with the external economic and objective pattern, had clinched and produced this crisis. Wallis had told them then that he was too old and too ill to look after himself any more and was going voluntarily into the workhouse—that he would not paint any more. He evidently meant this about painting, because he didn't take any materials with him, though he sent for them later.

I think that once he had entered Madron and settled down, his mind, having overcome and accepted the situation, was released from a good deal of pressure. But obviously he should never have had to face up to it. Long before this date his security from destitution should have been assured.

At that time I had come newly to Carbis Bay to teach in a school. It was there I saw a Wallis for the first time, hanging on the Quiet Room wall. I met Stokes and Nicholson and was shown their marvellous collections of his work: by this and their tales about this curious painter, I was very moved and became extremely excited. My one wish was to go and see him, quite prepared, out of my miserable wage, to squeeze a few shillings and buy a Wallis of my own. But this never materialized.

I said to Stokes: "I'm going to see Wallis to-day!"

He looked at me in surprise, then said:

"You can't. He's gone to the Workhouse."

To me this was appalling. On several occasions we discussed propositions for his rescue, but nothing practical was done. My suggestion that a collection should be made among artists and writers in England fell flat. Among the possibilities that came under discussion at the time were: firstly, to renovate Wallis' cottage and hire someone to care for him; Nicholson and Stokes inspected the cottage and interviewed Mrs. Peters with this idea in mind, but, apart from normal difficulties, the situation was further complicated by the war and proved impracticable. Another idea was to get him into a home for aged people, but no satisfactory answer was reached.

Subsequently, my personal life took a difficult turn and I was swept off into the centre of Zennor Moors with my family to face the winter under rigorous conditions, which left me with no strength or time to give to this matter. But even though it was crowded out of my life as a practical issue, it still remained forceful enough inwardly to urge me to begin research when and wherever possible, and make the notes which were the first foundation of this book.

In the following Spring, one evening after I had finished working on the fields, I cycled to St. Ives to do some shopping and call on a friend. As I went past Wallis' cottage I thought the front door was ajar. My friend proved to be out, and on my way back I purposely walked, pushing my bike, to see if the door *was* open. I tried it with a steady force—it did not yield: its old green face remained adamant, keeping its secrets—almost a symbol, for I had been trying the doors of Wallis' life for over half a year now, and no more than a glimpse of his true self had been granted me.

I noticed the downstairs window—through which, I was to learn later, the policeman had seen Wallis crouching by the fire, jabbering to himself, early one morning two or three years before; it was on a level with me, covered with dust, just showing a dirty lace curtain across the lower half. I rubbed one of the small square panes, and to my delight found that the dirt was on the outside and came away. I looked through—there was the room, just as he had left it. It was packed with things, like a lumber shop. In the centre was a black wooden table with a white porcelain drawer knob; the surface was covered with newspaper and strewn with papers and cardboards. Underneath was a box with a huge gilt-edged Family Bible sticking out of it. The walls were covered with paintings of boats—mostly by Wallis himself. One particularly I remember—it was larger than was usual for him—of a black steam-boat on a rough grey sea, but I could not see it very well. Had I been able to see the room more clearly I should have seen the photograph of Wallis himself watching from the opposite wall. On the plaster by the window I could see the little wall-paintings of boats, in black and white and brown.

By the fireplace was a kitchen chair with an old raincoat over the back of it, crumpled.

I remember a dresser, many books, more pieces of cardboard, but the room was very dark. It held so much—waiting there—soon to be dismantled, changed, painted, fumigated, and no one would care. This was the room where he had lived during the last twenty years, held court with spirits and painted all his pictures.

I have thought many times since of that empty room: it hung in my mind as an expression of all the poignancy, the beauty, the suffering and courage revealed in his life. The tenant was no longer there, but he had left behind him the imprint of his personality in a way that was at once so powerful and so humble that one could not help being moved. When our theories, our orations, our ideals and criticisms of life have lost their breath and subsided, one might turn to this room, because it tells us how a man, not interested in power and fame, riches and politics and praise, gave his life to the realisation of his own spirit. The marks of pain, of pathos, are everywhere to be seen; destitution lived with him in this derelict cell, this hovel, this home that he loved with so

much human affection. But also it tells of a singular triumph. This old mariner sailed the oceans through every weather, stood at his wheel when the cleft clouds rained down all the wrath of heaven and hell on him. He sat at his hearth till it was cold, then took up his things and went away.

13

Madron Public Assistance Institution stands like a "bastille" on the hills over Penzance: a group of tall grey buildings that have the austerity, the relentless indifference of an early nineteenth century prison or barracks. It is beautifully situated, with the village of stone cottages just below, the cemetery on the south-western side and the moors behind to the north. From the drive a view of the whole of Mount's Bay is commanded.

The buildings are divided off into sections, the men being segregated from the women, and in front of each section is a little walled-in courtyard where the old people sit and sun themselves. The grounds are fairly large and are kept by the men still able to work.

About the whole place there is a feeling of strangeness. All human emotion, all those peculiarities of form and colour that surround and permeate the objects and rooms we call home are, of course, absent.

There is no feeling of stress or tumult here, but rather one of repose—a peace that grows from rest, fatigue, acceptance of this place as the last asylum on earth where men and women wait patiently for death. This gives an unearthliness to the stone walls, that rise up in their terrible grandeur to the skies—and the very sunshine that falls in Madron is unearthly.

The dormitories, kitchens, living-rooms have a cleanliness that is noticeable —not the white, precise cleanliness of a modern hospital, but that of scrubbed boards, swept floors, dusted ledges. They are rather grim rooms. The paint on the walls is dark green for the first four feet, then cream, which is divided from the green by a wide black line. The ceilings are high and the windows tall.

Down the centre of the room in which Wallis lived during the day-time was a long mahogany table and several chairs. Against one wall stood a huge brown dresser, in which he kept his painting materials. I think I am right in saying that if the floors were not covered with a smooth brown linoleum they were bare. No other furniture was visible.

When I walked into that room there was one old man with white hair and a bright red woollen waistcoat, sitting alone at the long polished table reading a newspaper. As I went out with the Master, our footsteps sounded hollow, as they would in an empty house.

The dormitories were very little different, except for the black iron bedsteads, covered with white counterpanes. It is a curious experience to go into one of these dormitories and walk round the beds where the old men lie waiting. Faces with fallen jaws, smooth mottled skins, thin hair and red-edged

eyes; scraggy, bony-armed men; men with loose skin and huge bodies; little quiet men, resolutely waiting in silence, keeping their secrets; simple men with mild faded eyes, their minds now losing the capacity to function; aggressive, fussy, toothless old men; and others with nothing but the peace of acceptance in their eyes. From these faces come some of the sweetest and most beautiful smiles, some of the most restless and suspicious glances. A long chapter could be written on my visit to one of these rooms, but this is obviously not the place to do it.

The Master had been anxious that I should see from these windows the sloping hillside that is flooded with rhododendrons, blooming in April and May. He unlatched the door of a dormitory (I understood it to be the one in which Wallis died) and took me to see the view. It was then that I saw the old men. They were fishermen, sailors, farm labourers and workmen who had fallen out of the race; taken from their cottages and days spent on the harbour, forsaken by relations and friends. Here they had medical attention, hygiene, shelter, food, clothing, but no love. Perhaps they were too tired to want anything but death—perhaps life had already half-slipped away. Their struggle in society was over and they lived in a community where economic considerations were at an end, but I cannot believe this set them free, soothed away their agony, stifled their dreams, or dismantled the pride and fear which made the thought of their ultimate descent into the inconspicuous and despicable corner of the cemetery segregated and reserved for paupers any the less painful and difficult to face; for if a man of any station in life is worthy of his Maker it is impossible to conceive that he should, as a social reward for his days on this earth, be considered and treated as human garbage. To the paupers themselves there probably comes a time when even this no longer matters—certainly not after they are dead—but every corpse that is lowered into the earth with its fellows is an affirmation of the crime of society—the sin rests on *our* heads.

A little while after Wallis' entry into Madron, Adrian Stokes and Ben Nicholson drove over to see him. They found Wallis in bed, irritable and discontented—but he was pleased they had come. He had a grouse that he was not allowed to smoke or get up. His visitors interviewed the Master—at that time a different man from the present Mr. Stone—whom they found inclined to be "rather truculent." But, with diplomatic charm and courtesy, they succeeded in impressing upon the Master that Alfred Wallis was indeed an important person, who had paintings in the Museum of Modern Art at New York, and elsewhere: was, in fact, one of the best painters in England. Nicholson supported these statements with a copy of *Cahiers D'Art*, which he carried under his arm for the purpose. They arranged that Wallis should be given every consideration.

This, and subsequent visits from people of obvious standing, helped in swiftly making a *niche* for Wallis in his new life.

He was in bed about a month. When he got up he asked for painting materials. Margaret Mellis, Adrian Stokes and Ben Nicholson succeeded in getting them from the cottage at the considerable cost of carrying away an enormous number of fleas, which were the centre of a ludicrous comedy at Little Park Owles that afternoon. But again, the story would be irrelevant if recorded in full,* save that it offers indisputable proof of the condition in which the old man lived towards the end.

Nicholson tells me that Wallis' only attempt at community life was not unsuccessful: "they became very conscious of his personality and purpose, and those few who talked to me seemed to take an almost affectionate pride in him and his paintings, and said they were 'very clever.' A friend remarked to me that it almost seemed as if he had found some fulfilment in a community life."

Mr. Stone's opinion of Wallis was that he was "quite inoffensive and did not give much trouble," but confesses he had very little to do with him.

Against these reports I give that of George Manning-Sanders, who visited Wallis at the beginning of 1942—a man who has some insight into human character, and who is not always willing to be satisfied with the appearance of things.

Manning-Sanders may have chosen a bad day, for he found Wallis very aggressive and difficult to talk to: this was complicated by the fact that the conversation had to be carried on by messages written on slips of paper, which Manning-Sanders handed to the old man. Wallis took them over to the window, scowled and fussed and carried on:

"Can't read that! Can't read it! Can't read it!" he snapped aggressively.

The difficulty was that Wallis' sight was beginning to fail.

He took his new visitor to be "one of Them." He mentioned no names, but made continual reference to *Them*, *They*, *Him*. He might even have meant the Devil.

"Got 'undreds of my paintens 'e 'as! 'undreds ob'n. Goin' to make thousands a pounds!"

Apparently he was "insulted" by pots of paint that had been sent to him, and some paper that was slightly corrugated.

This probably refers to the colours sent to him by Nicholson and Stokes as a Christmas present. They had been to considerable pains to get the correct colours in "yacht paint" from the decorator, Mr. Burrell, who keeps the shop in the Digey, where Wallis had always dealt. But Nicholson tells me he simply refused to use them, saying they were the wrong kind.

* See extracts from Margaret Mellis's diaries, p. 19 *Artists from Cornwall*, Redcliffe Press, 1992.

According to Manning-Sanders Wallis had got in a rage over the event and thrown the paints across the floor: they had to be taken away from him.

Someone else sent him some water-colours: for these he had no use at all, besides which the French names of the different colours on the tubes worried him very much indeed. He packed them in a box, tied them securely with string and hid them in a far corner of the room.

While Wallis was pouring out his grievances to Manning-Sanders, the other old men in the room were putting their fingers to their temples and screwing them round to indicate that their companion was crazy. Old seamen that were there thought his paintings of boats were absurd and laughed at them.

Alfred's mind was not in the least coherent. Having classified Manning-Sanders as "one of *Them*," he finished by asking:

"What boat are 'e sailen on, Cap'n?"

"When I was leaving him," my friend told me, "there were about fourteen other old men in the room. I thought: 'Really, I must make an impressive and dramatic exit!' So I turned round, do you see—being half way to the door—and commenced this little performance of mine by waving goodbye to them all, when Wallis suddenly got up from his seat and began shouting in a most alarming manner:

"'Yes, you—you—you're as bad as the rest of en!'"

Here Manning-Sanders slipped beautifully into the Cornish brogue and began wagging his finger before him in imitation of Wallis.

"It was awfully funny. The old man had a little shrill voice:

"'Yes, *you*, Tas inside of 'e. The Devil. Firs' 'e der come with little things, a temptan of 'e, an' joggin' of yer elbow. Then with bigger things—until in ther h'end 'e der *win*. 'E'll 'ave 'e I tell you! 'E'll 'ave 'e! 'E'll 'ave 'e!'

"And of course," continued Manning-Sanders, "my exit was very much faster than I had expected, and not at all dramatic, I assure you!"

By his own confession, Manning-Sanders is not attracted primarily by the paintings (the value of which he thinks is rather over-estimated), but by the moving little tragedy that is centred round this old man. It was not until he had been over to see Wallis that he began to realise how very difficult he was, and did think for a time that perhaps it was better that he was in the workhouse. After all, he seemed quite happy. But this view was afterwards modified.

From these few stories it is difficult to get a complete idea of how Wallis lived at Madron, but they at least suggest the nature of his life.

As I walked into the sunny little courtyard in front of the building in which Wallis was housed, the Master pointed to a long weather-worn form with a table attached to it: three old men were sitting with their backs to the table edge, blinking in the spring sunshine—one, I remember, had his shoes off to warm his feet.

94

"That's where he used to sit and paint," said the Master, "when he felt like it, you know, and the weather was fine."

Then, turning, he pointed to a form in the far corner of the courtyard, where it was shaded and there was some ivy growing on the grey stone wall.

"Over there—that's where he used to sit and jabber to himself," added the Master, smiling. "Poor old chap!"

A good deal of painting was done at Madron and some excellent drawings.

The drawings were done mainly in greasy crayon—some in pencil. Nicholson had taken him four sketch-books, which he filled on both sides of each page in a very short time. These are extremely interesting. Although the soft paper and the smooth crayon proved too woolly a medium for him, he managed to produce some startling results.

For the sake of classification I gave each of these books a name when they were loaned to me by Adrian Stokes: the *Castle Book*, the *Grey Book*, the *Lion Book*, and the *Sharp Book*.

It is interesting to notice the various styles: the classic austere line of a drawing of a *Liner* from the *Castle Book* might be from the hand of some early Greek draughtsman. It is sensitive, simple and frail. The conceptual image reminds one of Picasso. The drawings of *Fishing Boats: PZ, L8L*, taken from the cover of the *Grey Book*, were, I thought, by Nicholson when I first saw them. The *Lion Book* is more tumultuous, presenting a curious turn towards the baroque; one notices the same thing happening in the later drawings of Van Gogh. There is a recognized tendency for pathological people to choose these wavy, sweeping rhythms of line, incorporating the spiral, the snake and the circle. As an example of the last the reader may turn to the drawings of Nijinsky.

In the *Scrap Book* there is the *Trees* drawing, done in very faintly-coloured line. One is at a loss to know how Wallis expressed so much dynamic strength with so strict an economy of means. With even less application in the *Viaduct*, he gives us a sense of infinity worthy of a Chinese artist.

It may be worth indicating the occasional similarity of Wallis' attitude to painting and drawing and the attitude of Far Eastern painters.

In the notes sent to me by H. S. Ede I find a quotation from a letter by Wallis which runs:

"The most you get is what used to be—all I do is out of my memory. I do not go out anywhere to draw. . . . I never see anything I send you now, it is what I have seen before."

The Chinese and Japanese artists went to nature only for the purpose of contemplation—they drew their vitality, understanding and experience from the objects they contemplated, but saw no point in making "drawings from nature." The adjustment of their vision was different from Wallis'—more

95

controlled, developed, more subjective—his was drawn from a world of *action*, not stillness. If you look at a painting of a boat by Wallis, as I have said before, you have the experience of seeing the behaviour of the boat from outside, and also of being in it: a boat on a mountain lake by a Chinese artist is the projection of the spirit into an everlasting universe. But he approached painting (the parallel with the Japanese Colour Print Artists is perhaps more apt) in much the same way—by drawing on the richness of experience he had gathered in the past. The little drawing of a *Man in a Sailing Boat*, by Wallis, is startlingly like some Japanese drawings. His point of vision chosen for the *Viaduct* drawing is the same as that used by Hiroshige in his *Monkey Bridge*.

Wallis was caged by action—that was his agony.

The paintings done in the workhouse along with those claimed by the authorities from the cottage after his death, were later sent in one batch to Adrian Stokes. This has made it more or less impossible, save in a few cases, to tell which ones were painted at Madron and which were not. It does not greatly matter. His last work was considerably poorer than the earlier things he did, owing no doubt to his failing eyesight and general decay both mentally and physically—also the attention given him by what he then thought to be important people probably gave him too much self-consciousness in what he was doing.

Adrian Stokes gave me several of these paintings. None of them was particularly good, but among them I found a batch of twelve pictures done on a chocolate-coloured paper, which at once struck me as extraordinary. Stokes first indicated them. We were sorting out a number of Wallis' things in his garage, when he picked up a few of these dark macabre-looking paintings and said:

"Look at these queer, funereal things he did towards the end!"

"Funereal" was apt—I understood at once. In fact it seemed for a moment I had discovered an extremely important key to Wallis' last days—I was right.

When I got home I spent a good deal of time with them, and was finally able to extract a sequence of eight, which I have called the Death Paintings.

There is a dispute over the time and place Wallis did these paintings—in the cottage or at Madron? Possibly this could be cleared up by the person who gave him the chocolate-coloured paper, but it seems too much of a detail to haggle over.

The fact remains that he left us a record of the process of death.

14

To die was such a logical conclusion to all that had gone before, and now that he was far more caught up in the stuff of his dream than he had been at any other time, it seems right that he should have tried to record this last passage before he passed out of our field of vision.

The important difference between these last paintings and others is that they are a record of an experience through which he was growing, as distinct from "what has been Before," which characterized the bulk of his work. That at least is partly truth, inasmuch as he was not re-living death, as he had re-lived life during the last seventeen years. Though we surely foreknow death at times, even fore-suffer it, and Wallis was nearer to death than most people because he was so much nearer to life, and his instincts, untrammelled by the scaffolding of intellect, were alive and developed. Death was often present at sea. Not the sharp instantaneous tearing away of the flesh from spirit like plaster from a wound, that is our pattern for to-day, but a slow and terrible voyage into the unknown.

In earlier years Wallis had sailed in a metal steamer through slushy brown seas to Labrador. Looming under a dark green, brooding sky, icebergs had towered over him—immaculate, inviolate, remote, passing silently in the night. Arctic winds had formed ice on the rigging, had cut his face and hands. He had steered through this to another continent.

Perhaps, in his mind, the memory of this voyage had always associated itself with death, its coldness, severity, and indescribable awe. And the metal steamer had been the very thing that had taken him into it: the antithesis of his world—the symbol of the advancing tide of civilisation: it spelt death. Whatever the case, it serves as a suitable pattern. The *Voyage to Labrador* is the one to which I refer.

Out of this pattern emerges the Iron Barge of the Death Paintings, reminiscent of the Black Barge of Avilon, and the frightful craft invented by Coleridge.

His senses were breaking down, he had half escaped from his body. The exchange was almost complete, and there was no repatriation.

One cold morning the Iron Steamer lay at anchor in the little harbour; the men stood on the deck waiting the order to move. Above them, on the green hillside, were the buildings of the Dark House under a cocoa sky—white pathways shooting down to the sea, unhesitating and direct. Two other boats, not yet ready to weigh anchor, swung idly on the tide.

Half a century after Wallis had sailed to Labrador he took the bridge once

97

more on the Iron Boat, steering it out to sea; but a sea that was no longer of this world, thinned to a transparent fluid, ghastly and cold, that broke on the rocks skirting the edges of life.

The ship dived down a hill of swollen water with precise and determined speed, turning its bows towards mid-ocean: the ghostly crew stood vigilantly on the deck, without any emotion, knowing no before and no after.

Could they have seen the shards of what had once been a multiple pattern, tossing in the foam behind them, pieced them together and recognized a face once loved, or fitted up the pathetic little cottage of thought and remembered the daily struggle for bread, they would have split from heel to crown—but they were frozen: bracketed in a space that knows neither time nor eternity.

Reaching deep water, where land was only tailored to them by the dark sea, with calm and majesty the huge ship drove on its way—a stable house, an ark carrying a cargo of dead men, on whom the dove would never again descend nor the leopard leap. They were intractable, adamant effigies without hope or haven, making a voyage where no discovery would reveal new wonders. They were dreamless and without desire, unknown and unknowable—their mission was to be missionless.

In this the macabre little community were together. The long vigil in those stone courtyards of the *Bastille* was over now. Soon the iron gates would close on the serious little processions that carry the carcasses away to the corner of the cemetery, and pile them in plain coffins, one on top of the other. It was best they had gone away before-hand, these old seamen, with their pride and gravity, for they belonged already to the dead, with those whom the sea and time and the world had taken before them. They were the last of their age, and there was no fear now: "Come," they had said to each other. "Come, Alfred, come, Matthew, we had best be goin'. Taz cauld, but the wind is fair an' the tide'll be right 'gainst marnin'. Let us be goin', yough!"

So they had left their useless bodies lined up in a row of iron beds in a room painted green and brown, that looked out on a hill covered with rhododendrons; left them to gaggle and squeak and grumble, smoking old pipes and listening to the news of a world at war, until such time as the valves burned out and there was silence. Left them and went down to the sea. Left them and sailed on an Unknown Ocean. At least, here was love, stirring them deeply, for this loneliness, this isolation, this utter surrender was what used to be and what shall become—peace and communion.

Swinging and creaking near to their iron craft a sailing boat passed to port. On its deck were the ghosts of men dead like themselves. The Captain stood resolutely amidships. The sails were clammy and transparent, touched by the cold wind that blew from the darkness with a hollow sound as though the sea and sky were a heaving bellows. The crew had deep experience. They were men

who *knew*, where others only believed. No longer neophytes, they had faced the void with the homeless and uncomforted spirit that wanders alone.

Then, as though struck with terror, the Iron Boat plunged into a fierce and frustrated sea, as the other craft swung out of sight—the last mutiny of the heart, rearing itself up in a struggle to escape. The Captain stood in the stern, unmoved, watching ahead. The ghosts remained passive. . . .

At last a new harmony was reached. The sea rolled smoothly round the boat, and out of it, like a finger pointing to heaven, rose the tall lighthouse.

The processes of renunciation were almost over. The world was now a distant green continent of pain, long ago forgotten.

Everyone turned, searching expectantly ahead. The boat had changed its colour—it was white—rushing through the sea towards a towering rock steepled by the pale lighthouse.

Only the crew knew what waited ahead. Only they could tell what the mystery held, leaving us with an unanswered question on our lips as they passed out of sight. There was darkness on the face of the deep.

Postscript

Alfred Wallis died of senile decay at Madron Institution on August 29, 1942. Within a year of that date Sebastopol had fallen again.

At his own request he was given a Salvation Army funeral—the arrangements for which were made by Adrian Stokes—and was buried in St. Ives Cemetery. The Institute had given no notification of Wallis' death until the previous day. Mr. Stokes' diplomatic and vigilant help procured a grave for him at the last moment when the coffin had already arrived, saving him from the pauper's corner. He now lies among respectable citizens and rich artists of St. Ives.

After it was all over Mrs. Peters came forward with £20 which Wallis had saved and given her to cover funeral expenses. This was claimed by the authorities.

The funeral was a queer little ceremony. Beforehand, Major Holley of the Salvation Army had been primed as to Alfred Wallis' gifts, and his speech in the enforced intimacy of the stone chapel gave a curious twist to the situation: words emulating the powers of the deceased, words addressed to the relatives who understood little, and to a handful of artists from the outer world, who, each in their different ways, saw the thing as it was: Gabo with the look of a man who feels seriously about death; Manning-Sanders with his roving eye, slightly cynical; Stokes with an expression that hid deeper things; Margaret Mellis with her own artist's vision; Bernard Leach, tall and grave; and Barbara Hepworth, pale and impersonal.

It is a strange place at any time: stark white crosses on a sloping hillside of the northern shore, flanked by Clodgy Point and the moors to westward, and the "Island" and grey roofs of the fishermen's town to the east—between these points the wide unbroken sweep of the Atlantic Ocean.

Cornish rain was drifting down, mingled with the smell of the gas-works and the sea by which Wallis had lived for so long, wetting the newly-dug earth, the bare-headed onlookers, the grass mounds, the ornate marble—all equally, impersonally.

Against this sombre background the flowers seemed unearthly.

NOTHING OF HIM THAT DOTH FADE
BUT DOTH SUFFER A SEA-CHANGE
INTO SOMETHING RICH AND STRANGE

Illustrations

COLOR

Between pages 48 and 49

I *Steamship in harbour* Crane Kalman Gallery, London.

II *White house and cottages* Kettle's Yard, University of Cambridge.

III *Small boat in rough sea* Kettle's Yard, University of Cambridge.

IV *Gateway* Kettle's Yard, University of Cambridge.

V *Cottages and trees* Mercury Gallery, London.

VI *Fishing boat off the coast* The Dartington Hall Trust.

VII *Trawler by quayside* Crane Kalman Gallery, London.

VIII *Trawler passing a lighthouse* The Dartington Hall Trust.

IX *Sailing boats entering harbour* Mercury Gallery, London.

X *Lighthouses and ships, St. Ives* Mercury Gallery, London.

BLACK AND WHITE

Between pages 32 and 33

1–5 *St. Ives c.1900* (Numbers 1–3 courtesy The Royal Cornwall Museum, Truro, Numbers 4 & 5, Wills Lane Gallery, St. Ives.)

6 *Charles Wallis, senior.*

7 *Alfred Wallis.*

8 *The rag-and-bone business* Andrew Lanyon.

9 *Susan Agland.*

10 *The rag-and-bone business* Peter Dryden.

11 *3 Back Road West.*

12 *Alfred Wallis c. 1938.*

13 *Facsimile of 'persecution' document.*

14 *Table painting.*

Between pages 72 and 73

15 *Two fishermen in their ship with one mast stepped* Kettle's Yard, University of Cambridge.

16 *Penzance Harbour* Kettle's Yard, University of Cambridge.

17 *Trawlers entering harbour.*

18 *Land, fish and motor vessel* Kettle's Yard, University of Cambridge.

19 *Lighthouse and two ships.*

20 *Boat with plane and airship.*

21 *Boats passing coast.*

22 *Saltash* Kettle's Yard, University of Cambridge.

23 *St. Ives Bay.*

24 *Ship passing lighthouse* Adrian Ryan.

25 *Boats with lobster pots.*

26 *Sailing ship and orchard* Kettle's Yard, University of Cambridge.

27 *Portrait of a woman.*

28 *Houses at St. Ives* The Tate Gallery, London.

29 *Three-masted ship* Kettle's Yard, University of Cambridge.

30 *Three-master in full sail near lighthouse* Kettle's Yard, University of Cambridge.

31 *Boats before a great bridge* Kettle's Yard, University of Cambridge.

32 *Tugboat* Mercury Gallery, London.

33 *Schooner and lighthouse.*

34 *Voyage to Labrador* The Tate Gallery, London.

35 *A 'Death' painting.*

36 *Ships entering a harbour* Mercury Gallery, London.

37 *Huntsman, hounds and house* Mercury Gallery, London.

103

Reprinted from Horizon, *January 1943*

ALFRED WALLIS

(Born August 18th, 1855; died August 29th, 1942)

IT is part of the incalculable crime of modern life that people still starve, still live in abject poverty. We have the Poor Law to guard these sad lives, it is true; but only those who have been forced to use this law know the inadequacy of the help it extends, the unsympathetic indifference of those whose business it is to put it into operation, and the interior agony of the human being who has sunk so low on the social scale – from whatever cause – that he must apply for relief from destitution, or struggle along on the Old Age Pension, finally to enter the workhouse infirmary when age, sickness and suffering have done their work of destruction.

To an artist this agony is tenfold, because of his increased consciousness of life and his innate sensitivity.

To the mind of a Cornish peasant, who is still insular, still in need of an impossible secular paradise (as indeed so many of us are at heart), who is in terror of hellfire and damnation – a tribe that has for centuries worked on the fields and sea with the stubborn persistence that characterizes the crude instinct to breathe and move (for ever under the threat of the invading foreigner) – to such a mind the thought of the Dark House is always present, with the primeval fear of extinction.

Working on the fields of Zennor during the winter I have seen men drop to the ground beside me rather than give in to the cold and hard work. It is the ancient fear of starvation, the stern morality of their religious upbringing that keeps them going – the fear of destitution, fear of the 'Boss', fear of the Saxon, the Roman, the Dane, the Old Testament God – it is all the same: this fear moved in the dim brains, stiffened the damp fur of these men at a time when their bare claws were split on mica jutting from the rock.

So it is that an ancient mechanism has been put to a modern political use.

The reason why a Cornish peasant – the miner, the farm labourer, the fisherman – so often became a drunkard or an intensely religious person, or both (the St. Ives fishing community was always split up in this way), had its roots in the economic conditions that kept alive this deeply ingrained fear.

The Cornish are an emotional, literal people with no art of their own through which to free themselves; these compensations have therefore become necessary to balance the psychological conflict set up by the severity, insecurity and peninsular nature of their lives, which are largely a result of the geographical position of Cornwall.

This has bred a hard, mercenary, suspicious, clannish, but independent and vivid race of people, who are, however, kind and helpful to one another and show

fine qualities among themselves. In spite of their hidebound morality they have a profound love of the fields and sea, 'their gear and tackle and trim', for in these is the source of life, closely bound to the balancing economic and religious poles – that is, material existence, and the need for personal survival after death; in this is manifest the spirit of their clthonic God, who can save or damn them.

At a time when our eyes are set on the larger outside world, individual lives being counted for so little, it is perhaps of small relative importance to record the death at the Public Assistance Institution, Madron, on August 29th, 1942, of Alfred Wallis, aged eighty-seven, a St. Ives marine rag and bone merchant; he was buried in St. Ives Cemetery a few days later, mourned by two or three relatives, and a few artists who believed in the pictures he painted.

Alfred Wallis was born at North Corner, Devonport, on August 18th, 1855, the son of a master paver; his mother was from the Scilly Isles; she died when he was too young to remember her. The family were extremely poor, and at the age of nine he went to sea on the light schooners and windjammers of that time; later he worked with the St. Ives fishing fleet as one of the crew of the *Two Sisters* and the *Faithful*, boats which made voyages to the North Sea.

The only authentic tale of a 'deep blue' voyage by Wallis is of a trip to Newfoundland, where they loaded a cargo of Newfoundland cod; on the return journey the ship ran into a heavy gale; half the cargo had to be thrown overboard to save the men's lives. This experience made a powerful impression on him; he was reported lost, and the subsequent shock to his wife resulted later in the death of one of his children, who lived, however, a few months.

During this time he lived at Penzance.

In after years Wallis set up his business as marine rag and bone merchant in a cellar at No. 4 Bethesda Hill, behind the wharf at St. Ives, buying and selling junk from the fishing boats and the town. The whole community he knew well – was, indeed, part of it – but he was a very retiring quiet man, and later, when the business was gone and his wife dead, most people came to look upon him as a queer and difficult person, which he undoubtedly was. There was something in Wallis's soul that was unresolved, and throughout the gradual development of his life one sees him all the time searching for fulfilment. As is well known, a society will always tend to exterminate the unusual or abnormal individual; often such an individual is the most sensitive part of that society. These things increased Wallis's unhappiness. Some say that even as long as forty-five years ago he was the butt of children's fun: children who are now themselves hardened fishermen and farm labourers.

He began to go queer in the head, especially when 'the moon went over'. It was at the time when wireless first became popular, and he developed what he called a 'wireless brain': he said voices got inside his head telling him he was a 'damn Catholic', a Methodist, and so on, each voice representing a different religious sect that was trying to drag him from his own belief in the Bible. As years advanced he was forced more and more inwards on the course of self-immolation, which was in itself a direct result of religious upbringing in childhood, only to be added to by

the continual impact of circumstance on his mind throughout life. To make matters worse he went deaf. He grew morose and excluded the society of almost everyone.

Wallis married a Mrs. Ward, formerly Susan Agland, from Seaton, near Beer in Devon; she was trained in making Honiton lace, was 'strong Salvation Army', and twenty-one years his senior. There were seventeen children by her first husband, five of whom were living when she married Wallis, but only two by Wallis himself, both of whom died in infancy. Alfred was looked upon by Susan as another child – to him she was his 'Mother'. He was good to his step-children, though in later years he became estranged from them. With sanctity and respect for the dead, they now speak of him as a good living and kindly man; they tell how he behaved to them as though he were their real father when they were young; it must have been a great sadness to him that he was not.

It was not until several years after his wife's death, in 1922, that he started to paint: he was then over seventy. The step-children had died or married – he was completely alone.

Among other things his painting was a supreme effort to put himself in the place of the father, the creator, a function of which life had so far managed to deprive him.

In his little cottage in Back Road West he set to work, painting not only on the strips of cardboard he used, but also on the walls, the woodwork, the table, bellows and jam-jars. The passion held him: he was the tool; he worked with humility. The outward, 'bible-punching' personality of Wallis that presented itself to some was not real, or at most only the conscious shell of the true man who, in the final issue, achieved the act of unselfing. Wallis was as sincere and gentle about his private approach to religion as he was about his painting, but valued it far more highly.

Until just over a year ago one might have seen this cantankerous little man sitting at his door or in his front room hard at work. Occasionally visitors went to see him – it was fun; but the few people who bought his paintings did so because, quite genuinely, they took pity on him or admired his work. The Cornish people looked upon him as queer in mind. The members of the St. Ives Art Society, with their academic distinctions, their hidebound, unprogressive attitude to painting, when they noticed him at all, considered him as quite unimportant, and smiled at his work like condescending giraffes. From his relations he would accept no help; one of them said of him, earnestly though not unkindly: 'Alfred Walls got what he looked for; he looked to be without a friend; he died a hermit'.

Wallis was first 'discovered' by Ben Nicholson and Christopher Wood in the summer of 1928. In the work of these famous artists we read clearly the debt they owe him: I refer to the Cornish landscapes of Nicholson and the Breton and Cornish seascapes of Wood. Several artists have benefited pictorially by Wallis's achievement. The admiration extended by this circle, headed by Nicholson and Wood, was an encouragement to Wallis, because they were the only people who believed in his work, though it had little effect in ameliorating his circumstances.

His paintings found their way into many private collections, also the Museum of Modern Art at New York has him represented; he is reproduced or referred to in contemporary art histories and books on art, such as *Art Now* by Herbert Read, *Colour and Form* by Adrian Stokes; but the artist himself benefited in no substantial way from all this – such things as publication and exhibition had no meaning for him; his works sold for no more than a few shillings each, and no increase in personal security was forthcoming, which was the keystone to his life, as I hope to show.

His pride in standing in his own home counted for much: it stood for the things he most deeply loved – painting, the sea, and the fireside – which were symbols of life and life unending: but soon these were to be taken from him.

He continued to work on among his fleas and filth, eating little (two 2½d. loaves lasted him a week, and his grocer's bill never came to more than four shillings), doing his own washing and cooking, save for the help given him by Mrs. Peters, next door, who was the only person from whom he would accept assistance. This lasted until the summer of 1941, when he entered the workhouse, saying he was too old and too ill to continue alone any longer. The doctor had been called in to attend him for bronchitis; finding him in such a filthy state, sleeping on an old couch but as far away from the fire as possible because of the voices that came down the chimney, the case was reported. Wallis made no resistance: 'I don't care where I go to be looked after!' he said, and when the time came he was dressed up and waiting to be taken away. He took with him only his watch, his magnifying glass and his scissors.

While he was in the infirmary an eye was kept on him by some of those who had bought his paintings, which made conditions a little easier. Materials were sent for his work. In fourteen months he was dead. After his death it was discovered that he had left £20 for burial purposes, which the authorities claimed, to cover expenses, but his admirers had already saved him from the common grave. He now lies among the expensive gravestones of respectable citizens and rich artists.

'I am not a real painter!' he said of himself; by which he meant that he did not understand painting as the local Society understood it: the work of these people and the coloured reproductions of ships he had on his walls comprised his entire knowledge of art; it is certain that he never saw the abstract equations of Nicholson or the spatial constructions of Gabo – the only major influences working in the district – or that he would have understood them if he had. It is even questionable whether he ever saw a good painting. In making this modest statement about himself he tacitly confessed that he was practically without influence of any kind, and was therefore free to follow his own vision. It is known, however, that he copied from old prints, which he obtained from a local junk shop by putting in a few days' work by way of payment.

All he had otherwise was a passion to paint, *and paint he did.*

With the scanty, self-acquired technical equipment of a child, with materials collected from the dustbins and beaches – odd shaped pieces of cardboard, paper, leather, wood – usually with ordinary ships' paint, which he preferred, and a

pencil, he set about the immense task of becoming articulate, of putting down his titanic passion for the earth and sea; with this *love*, hemmed in by loneliness, the threat of extinction, and the strictest economy of means, he produced paintings of a unique kind: paintings that had new and unsuspected formal and colour relationships, new structure, design, texture and organization, bound together by an unquestionable sincerity and directness, expressing the fervour of a true artist, with, as Herbert Read says, more naïveté than Rousseau. Although it may be said by some that the pictorial excellence of his work was apparently fortuitous, and a result of his central innocence and intellectual ignorance, there was, nevertheless, a hidden intuitive guiding force at work. His paintings came into being from no other source than his own creative soul, as though he had said:

> 'Where got I that truth?
> Out of a medium's mouth,
> Out of nothing it came,
> Out of the forest loam,
> Out of the dark night where lay
> The crowns of Nineveh.'

Wallis, in his own context, like Cézanne, was the 'Primitive of the way he discovered'; he was also a Primitive in the real sense of the word; as much a Primitive as the artists of Altamira, whose powerful vision still comes charging down the ages. He was the Primitive of the twentieth century. Only an unassuming and rugged nature could have produced such work in an age of so much barren, self-conscious, intellectual snobbery and power.

It is difficult to assess exactly what Wallis thought of himself as a painter, but he did believe there was 'something in it'. Certainly he considered it his first duty to obey the law of the Bible, and occasionally to teach others the way to avoid the nets of the devil. About this he was emphatic. If you went to him on a Sunday he would be found in his little room with an enormous family Bible open on the table before him, and all the paintings covered over with newspaper; the conversation, if he let you in, would be about religion, not painting – as indeed it would be on many occasions – and like many old Cornish fishermen, he could quote chapter and verse from almost any part of the New and Old Testaments. Should you have asked him to sell you a painting on the Sabbath he would have refused, just as surely as, until quite recently, some Cornish farmers would not go out to save a field of hay on the Seventh Day.

Painting began as a hobby to fill the lonely hours: a method by which he might gain pleasure and become later a means of earning a few extra shillings – probably he always thought of it in this way – but in reality it was a deep psychological need: his mind was finding another way out of the tangled primeval fear, which poverty kept alive: a creative counter-weight to the destructive forces working in him through religion.

He painted the past, the sea, because to do so was an affirmation of *life*. In the storms and thunder of his seas, his lonely boats, we are given the whole conflict

of his soul resolved into an organized equilibrium and harmony, the means completely and absolutely welded to the content.

His moral attitude had its effect also on his work. His colours, though conditioned by material means and limited knowledge, were at the same time controlled by a puritanical eye, which gave him a great simplicity and faithfulness of observation. Black, green, white, ochre, occasionally introducing pink or blue, were practically all the colours he used, and he seldom used more than three of these at one time. The foundational, natural colour of the ground he worked on was always used to the best advantage; some of the results, for instance, arising from the use of black and white oil paint on a piece of brown or dingy yellow cardboard are astonishing. It was nearly always his practice to paint the sea grey or white, pointing out that if you took a glass of sea-water and held it to the light it was not green or purple or blue but *colourless*. He was *literal*; this word characterizes the man's work right though.

In a scene with fishing boats or trawlers he painted lobster pots, and large fish the size of dinghies, supposed to be below the water; they were *there*; it was a factual representation of an economic need, and they lived with a rhythmic vitality of their own. There was no muddled thinking or nebulous emotion with Wallis: he was a stern realist; it was with real problems he struggled.

To paint the reflected colour of the sea was to paint the outward scenic show, which he was not interested in. He understood his Bible when it taught him 'Charity vaunteth not itself, is not puffed up'.

To study the painting of a ship by Wallis is to see with what artistic conscience he set about his task, observing the truth of the rigging, the structure and behaviour of the boat. In spite of the immense psychological and technical obstacles that always faced him, like a heavy sea flinging him from his course, he struggled to get it right.

The austerity that grows from this tortured man seeking his salvation is the product of an effort to be absolutely true to himself.

The analysis of his mind cannot be clear cut, it can only be said that for him, daily life and art were closely related in the structure of his moral and religious thought. It was by means of a disciplinary framework and ceaseless application – to achieve which, in one way or another, is a task for every good artist – that he was able to communicate the spirit of those elemental qualities, of which at root we are all part. It was in this deeper thing that he touched God.

An artist is a nerve centre for his age, a focus-point of awareness for the society in which he lives. This was true of Wallis. In his work we are told the story of men at sea, facing its dangers, enjoying its benedictions of beauty, of peace, of meagre economic reward; of men working in a well ordered community until it was squeezed out of existence by the gradual progress of modern politics and finance. He gave us also the entire peculiar otherness of life at sea.

With a poet's imagination he creates for us new images, carrying new experience and meaning, which are, however, strangely and deeply familiar, bringing once more into the stream of human development a solution to the problem of

reconciling the imaginative and material worlds of being, charging them with the same force of life, so creating for us a wider consciousness and understanding of life itself, and revitalizing the stream of human creative endeavour. The fact that this achievement was mainly unconscious is the greatest part of it. His life was a religious discipline in a real sense, and in its final reckoning a sound proof of the value of inward self-realization as a way of rendering lasting service to society as a whole – in doing this the outward self was destroyed.

It is on such achievements that the value of a man and a nation may be ultimately judged. But for such a one – our humble Ulysses – there is no reward other than the lamentable gifts of the Board of Guardians and the cold comfort of the workhouse infirmary.

Such tragedies have been enacted too many times in history to be excusable. That the expression of our human genius is not recognized at close quarters is often true, but not so with Wallis. And why should a man have a unique talent in order to claim his birthright to live? Whose duty is it but that of the State and society to keep such men as Alfred Wallis from poverty and mental anguish? In the great struggle to preserve our ancient heritage we forget the very source from which that heritage springs – the human heart that is beating *now*, and is the pulse of the race.

SVEN BERLIN